IMAGES
of America

CATHOLIC CHURCHES
OF DETROIT

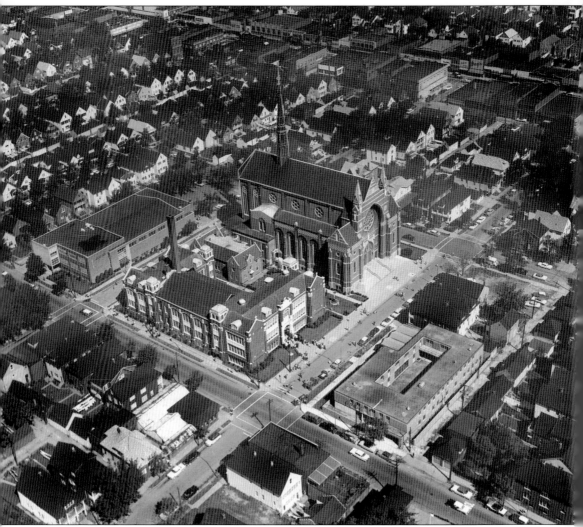

In a scene reminiscent of medieval Paris or Cologne, the massive physical plant at St. Florian dominates the tidy working class neighborhood in the Polish enclave of Hamtramck. Founded in 1907, St. Florian is Hamtramck's oldest parish. The present church, shown here, was designed by famed Boston architect Ralph Adams Cram. Construction commenced on the neo-Gothic structure in 1925 and was completed by 1928 for what was then the hefty sum of $500,000. Over 10,000 people attended the solemn dedication ceremony, led by Bishop Michael Gallagher, on October 21st of that year.

IMAGES
of America

CATHOLIC CHURCHES
OF DETROIT

Roman Godzak

ARCADIA

Published by Arcadia Publishing
Charleston SC, Chicago IL, Portsmouth NH, San Francisco CA

Printed in the United States of America

Library of Congress Catalog Card Number: 2003115648

For all general information contact Arcadia Publishing at:
Telephone 843-853-2070
Fax 843-853-0044
E-mail sales@arcadiapublishing.com
For customer service and orders:
Toll-Free 1-888-313-2665

Visit us on the Internet at http://www.arcadiapublishing.com

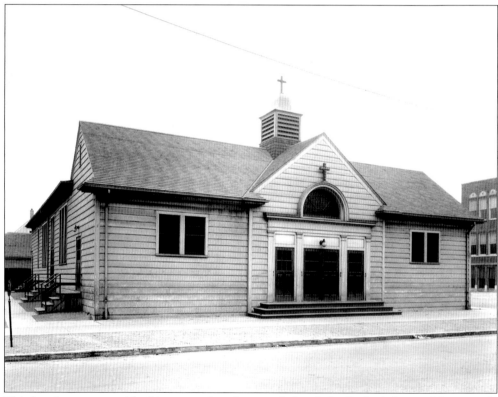

This hastily constructed building served as the initial church for St. Ladislaus in Hamtramck, founded in 1920, as more Poles settled in what was then a rapidly growing suburb. In some cases, these temporary structures continued to serve for a while as school gymnasiums or activities centers, but if it became necessary to assemble a larger parcel of land to begin construction of the permanent church, they were immediately demolished.

CONTENTS

INTRODUCTION

The word *Church*, in its broadest definition within Catholic teaching, means the collective body of the faithful around the world, under the spiritual leadership of the Holy Father, the Pope. In its narrowest interpretation, it means a distinct building set apart for the express purpose of public worship of God, the celebration of the Liturgy, and the reception of sacraments. For most persons, the latter definition of *church* is the most endearing and enduring.

When French settlers landed on the banks of the Detroit River in 1701, they encountered an untamed wilderness filled with hostile inhabitants. Their first priority was to build a haven in this strange, new environment—and from this sanctuary, venture forth to carve out an orderly, productive existence. It can be speculated that their second priority was to erect a church that would ensure the continuation of those ancient rituals that were a part of their daily lives. That first church, dedicated to Sainte Anne de Detroit, was a primitive log chapel but its symbolic value belied its appearance. It was a public pronouncement to the rest of the world that Christianity in this part of North America was here to stay.

The beginning of the 19th century witnessed the first influx of non-French residents into Detroit. Irish led the migration, followed by Germans and Belgians, then later, Poles and Italians. Modern scholars may ruminate on the great American melting pot, but in reality each ethnic group was determined not to become overshadowed by another and lose its identity. In their eyes, the church was the key to preserving the time-honored traditions and customs of their native lands. For a brief time, Irish may have grudgingly attended Ste. Anne or Belgians may have reluctantly become intertwined with Germans, but sooner or later, every group filled the bishop's ears with cries of, "We want our own."

Nearly every new parish began in a similar manner: a simple structure temporarily served as a church until sufficient funds could be raised to construct a more fitting edifice. As new ethnic groups made the city their home, it became an undeclared contest among them to see who could erect a more spectacular building, creating the dubious impression that these particular people were more sincere in their faith because they were more generous. On the other hand, this competition, as it were, provided irrefutable testimony to the degree of importance each group placed on having its own church.

The story continued in identical fashion for every wave of immigrants that came to Detroit. By the early 20th century, it seemed every third or fourth street corner had a Catholic church on it, each serving as the neighborhood landmark. The arrival of the automobile age further cemented Detroit's national reputation as an industrial center, drawing even more people

seeking the American dream to the city. During the episcopate of Bishop Michael Gallagher (1918–1937), nearly one hundred new parishes were established throughout the diocese.

For the better part of the 19th century, European immigrants comprised the city's new arrivals but the early decades of the 20th century witnessed more African Americans and Mexicans putting down roots in Detroit, as the rapidly expanding auto plants were desperate for more laborers. The diocese did not ignore their presence. Missions attached to already extant parishes became *de facto* churches for these groups, catering to their particular ministerial needs. By 1938, African-American Catholics were of a large enough number on the east side that Archbishop Edward Mooney arbitrarily turned control of Sacred Heart Parish on Eliot near Mack over to them, while Mexicans grew in number in southwestern Detroit and gradually became an increasing percentage of the congregation at Ste. Anne, Holy Redeemer, and St. Gabriel as the original European members departed the neighborhood.

The years after World War II saw an increase in the movement of people from the confines of Detroit's older, congested neighborhoods for the more open spaces of the suburbs. Although the Catholic presence in rural Michigan had existed for many decades, it was now the methodical development and expansion of suburban communities like Warren, Farmington, Redford, St. Clair Shores, and the lake resort areas of northern Oakland County that compelled the establishment of new parishes.

When the Second Vatican Council convened in October 1962, it set the Catholic Church in a new direction. One outcome of the Council was a directive that de-emphasized the lavishness that had become the standard in church architecture. Guidelines were established that essentially reminded the faithful that the church building was a means to an end, not an end in itself. New churches were far more functional than ever before with a less restrictive interior, often circular in shape, that allowed the faithful to feel closer to their priest in the celebration of the Liturgy and engendered a feeling of unity. At first, the new architectural styles did not sit well with traditionalists, accustomed to generations of classic European designs. There are undoubtedly those who, even today, bemoan the loss of the good old days and find it difficult to identify with current aesthetics.

The exodus from Detroit, meanwhile, continued unabated. In most cases, it was a matter of individual choice. In other instances, relocation was forced upon certain neighborhoods as cities across the nation in the 1950s and 1960s embarked on massive urban renewal programs funded by federal grants that replaced what had been the old ethnic enclaves with gleaming new office buildings, apartments, or modern industries. The Detroit riots of 1967 were a watershed in the city's history that forever altered its landscape and, perhaps more significantly, the mindset of its residents. The demographic shift from the city proper that began as a trickle, then a steady stream, now became a torrent as the middle class—both black and white, the backbone of any city's tax base—fled in droves for the perceived safety beyond Detroit boundaries. Businesses soon followed, further reducing the city's ability to sustain itself.

When General Motors approached the city of Detroit in 1979 with a plan to build a new assembly plant with its promise of much-needed jobs, the offer was too good to ignore. The city set the process in motion by acquiring land for the project. What made this otherwise routine procedure so salient was the resulting interpretation of the constitutional principle of "eminent domain," the seizure of private property for the public good. Opponents of this land grab sued, claiming that General Motors, a private, for-profit corporation, had no right to acquire land in this manner. The presiding judge in the case however, ruled that the creation of jobs in an economically depressed city was beneficial for the public. His ruling established a new precedent in American jurisprudence.

At the center of this historical debate was a relatively obscure parish called Immaculate Conception, at the corner of Moran and Trombly. Slated for demolition in the summer of 1981, it became a celebrated cause when a small group of both current and former parishioners rallied to defend their beloved church from the wrecking ball. Immaculate Conception came to symbolize what some people saw as a big, heartless corporation running roughshod over the

little guys. Despite the daily media barrage of crying parishioners and picket signs, however, the GM project proceeded as planned and the parish closed.

The decline of Detroit reached what might arguably have been its nadir when in September of 1988, the Archdiocese of Detroit made the shocking announcement that 43 parishes were targeted for closing, proving that even the Church was not invulnerable to the city's pronounced demographic shifts. The irreversible common denominator shared by these parishes was a combination of shrinking numbers of parishioners, declining offertory, expensive upkeep for aging buildings, and duplication of services and programs that put a severe strain on limited resources. Although unfairly vilified in many people's minds, Cardinal Edmund Szoka fully understood the circumstances involved and proceeded with the painful, controversial plan that garnered national attention. After a lengthy appeals process permitted under canon law, Detroit, between March 1989 and July 1990, lost 30 parishes.

The phrase "leaner and meaner" may be acceptable for corporate America but not the Catholic Church. Leaner perhaps, but certainly not meaner. Despite the loss of so many parishes, the mission of the Church has not changed. To serve, to guide, to assist, to console, to uplift, these ideals remain constant as the faithful remain steadfast. As the 21st century unfolds, one can see a gradual reawakening in Detroit, peering over the horizon like a new dawn. Hope becomes a vision, a vision becomes a plan and a plan becomes reality. Those who never stopped believing in the city will be there to see it happen. The Church will be there among them.

Roman Godzak
October 2003

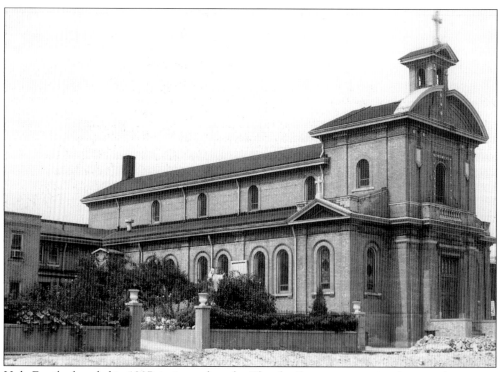

Holy Family, founded in 1907, is situated on the Chrysler Expressway service drive on the eastern fringes of Greektown. Despite the loss of much of the surrounding residential neighborhood over the years, the parish continues to serve the Italian community throughout the metropolitan area. Since it was founded, the parish has been staffed by the Benedictine Fathers.

One

DETROIT
TRACING THE ROOTS OF CATHOLICISM

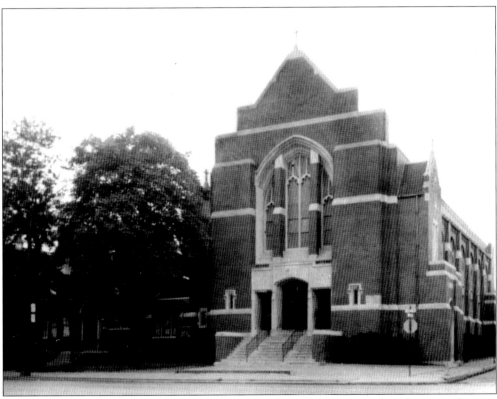

All Saints, founded in 1896, is the oldest parish in the Delray section of southwestern Detroit. Situated on Fort near Springwells, the expansion of southbound I-75 permanently transformed the area's landscape from primarily residential to industrial. A devoted congregation has kept the parish alive despite its seemingly inhospitable environment. The present church, shown here, was dedicated in August of 1926.

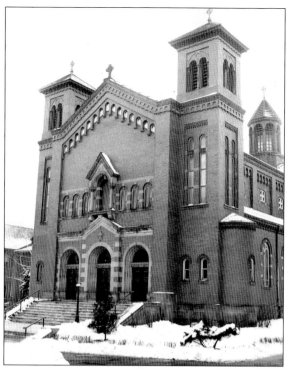

In 1906, the sparsely settled east side of Detroit became home to Annunciation, located on Parkview between Jefferson and Kercheval. The parish held its first services in a former Protestant church. Annunciation grew to 5,000 members by the early 1920s, many of whom were successful entrepreneurs and educated professionals. Pastor Msgr. Wilbur Suedkamp (1968–1987) pioneered the development of affordable senior residences known collectively as the Ryan Homes.

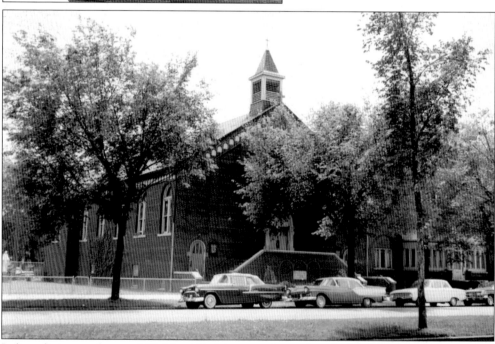

Italians living northwest of Highland Park became the nucleus for Madonna Parish, opened in 1924. In the 1950s, Madonna was the temporary home for Maltese displaced from their older inner city neighborhoods. Situated at 12th and Oakman in one of Detroit's most economically depressed areas, Madonna was the home parish for Fr. William Cunningham, the visionary founder of Focus: Hope, one of the best known job training programs in the country.

Hungarians settled in southwestern Detroit to labor in Delray's factories. Holy Cross, on South Street south of Fort, was established for their needs in 1905. Hungarian-born Henry Kohner designed this neo-Gothic edifice, consecrated by Bishop Gallagher on September 20, 1925. In recent years, the parish has purchased several vacant lots adjacent to the church and installed attractive landscaping, creating an urban oasis in an otherwise impoverished area.

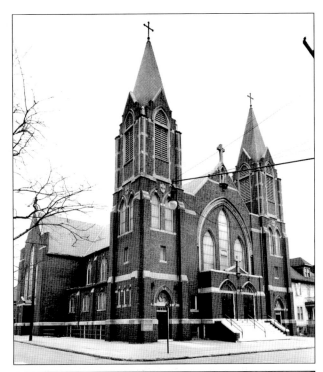

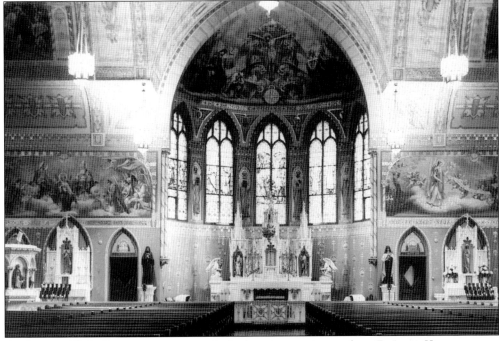

At the time Holy Cross was consecrated, the interior was incomplete. Fr. Louis Kovacs, pastor at that time, envisioned an ornately detailed worship space. His death in 1927, the Depression, and World War II postponed the work until 1948 when Hungarian artist Andras Daubner was commissioned to create a series of murals throughout the interior. The murals honored both the Catholic faith and Hungarian culture.

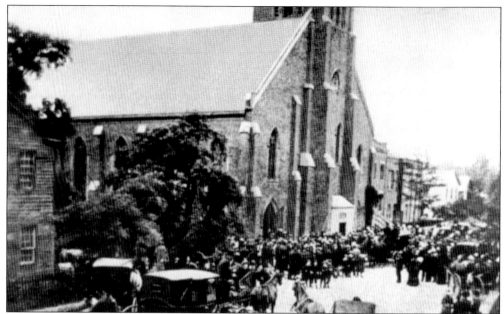

Most Holy Trinity (1834), at Sixth and Porter, was the first English-speaking parish in the city, founded for increasing numbers of Irish immigrants who flooded Detroit in the early 19th century. Here, the faithful arrive on foot and by carriage for services c. 1875. In that same year, Holy Trinity became the first Catholic church to have electrical lighting. The exterior, as depicted here, remains nearly unchanged to this day.

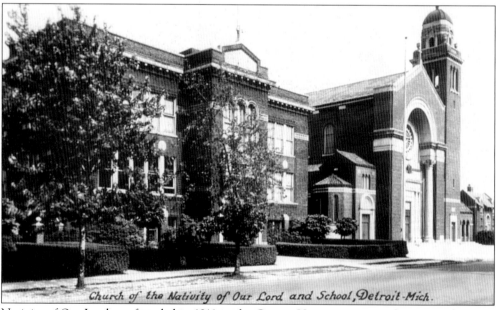

Church of the Nativity of Our Lord and School, Detroit-Mich.

Nativity of Our Lord was founded in 1911 in the Gratiot-Harper area, once known as the town of Leesville, later annexed by Detroit. Presently located on McClellan and Shoemaker east of Gratiot, this Renaissance revival-styled edifice, designed by Vanleyen, Schilling & Ledugh, resembles the basilica of St. Francis D'Assisi in Assisi, Italy. The first service was held in 1926 but the church was not completed until 1929.

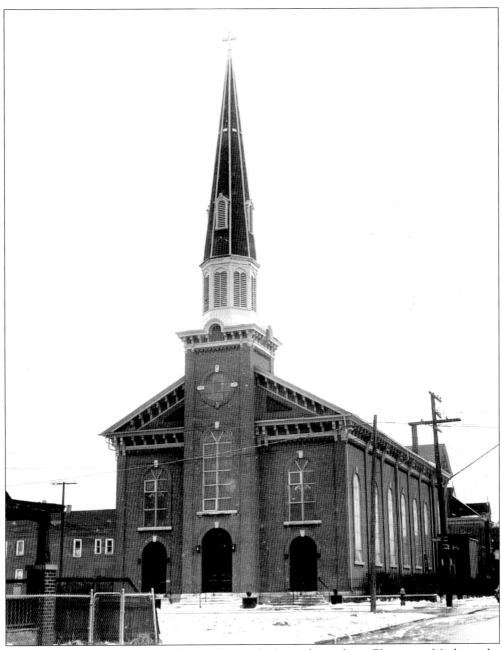

German-born Peter Dederichs designed Sacred Heart, located on Eliot near Mack at the northern end of Detroit's Eastern Market. The structure symbolized the traditional German national character with its uncomplicated, robust lines. Sacred Heart began as a German parish in 1875 but in 1938, it became embroiled in what was then a major controversy when Archbishop Edward Mooney declared it the new home for east side African-American Catholics. Despite initial resistance and resentment from long-time German members, Sacred Heart has since grown into one of the most prominent African-American parishes in Detroit with a distinguished history. The majestic steeple was destroyed by a severe windstorm in March 2002 but has since been rebuilt.

13

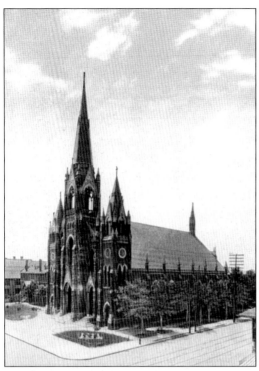

Founded in 1880 to serve German and Irish farmers living in what is now southwestern Detroit, Holy Redeemer, on Junction near West Vernor, grew tremendously in the late 19th century. This magnificent Gothic structure, dedicated in 1897, was deemed inadequate only two decades later. It was demolished and replaced with the present church. Holy Redeemer now serves Detroit's Mexican community.

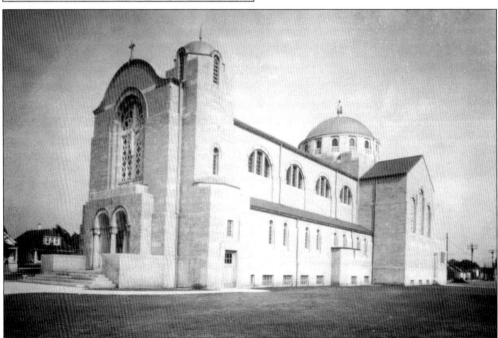

Hamtramck's Ukrainian residents established their parish, Immaculate Conception, on the city's south side on Grayling in 1913. As the expanding congregation outgrew its original church, it relocated near the northern boundaries on Commor between McDougall and Charest and dedicated this cruciform structure in 1941. The rounded dome, typical of Byzantine architecture, is visible at the rear.

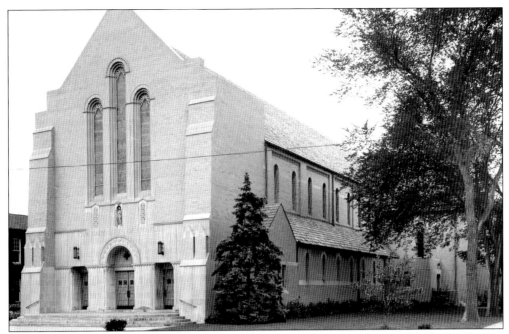

The founding pastor of Our Lady Queen of Apostles in Hamtramck (1917), Fr. Roman Klafkowski, personally visited the homes of Polish residents in the city's east end to generate support for a new church. He was able to raise sufficient funds to purchase 32 individual lots that comprise the parish property today. The present church, located on Conant north of Caniff, was dedicated in 1952.

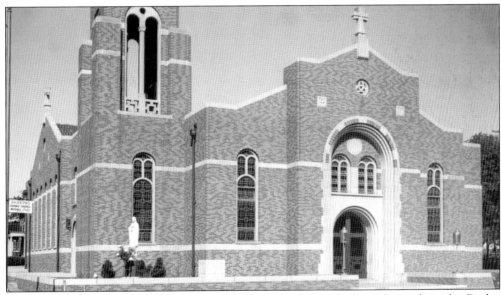

As more Polish immigrants flocked to the Hamtramck area looking for work in the Dodge Main plant on Joseph Campau, the need for an additional parish to serve them became imperative. St. Ladislaus, the city's third Polish parish, was founded in 1920. The present church, on Caniff and Brombach about one-half mile east of I-75, was designed by Arthur Des Rosiers and dedicated in May of 1954.

Originally located on Charlevoix and McDougall on the city's near east side, Our Lady of Redemption was founded in 1920 for Detroit's Melkite community, composed of Arabic-speaking Catholics from Syria, Palestine, and Egypt. The parish has since relocated to Warren, near the Twelve Mile-Van Dyke area.

St. Aloysius, founded in 1873 and located in the heart of downtown Detroit on Washington Boulevard, served as the diocesan cathedral from 1877 to 1890. The present church, shown here, designed by Donaldson and Meier, was dedicated in 1930. Artist Corrado Parducci sculpted the ornate façade that includes the figures of the twelve Apostles and the massive rose window above the main entrance.

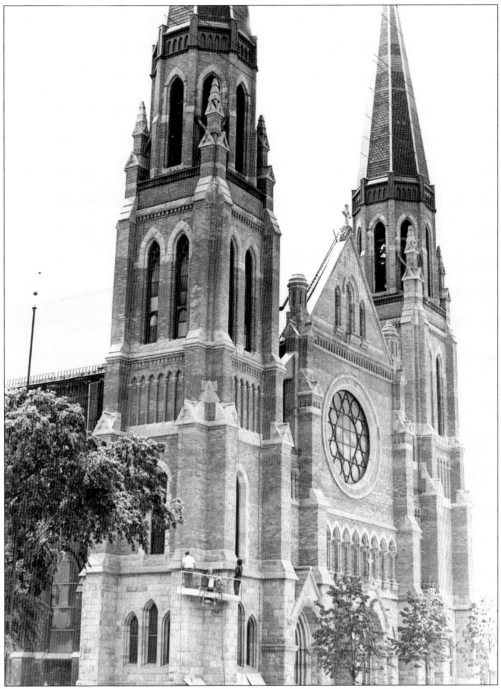

Standing on the scaffold near the base of the steeple at left, workmen are dwarfed by the classic Gothic structure of Ste. Anne, located near the foot of the Ambassador Bridge in southwestern Detroit. This particular edifice, dating to 1886, is the seventh version of the famed church, the city's first house of worship. Years of deterioration threatened its very existence by the mid-1960s, but a determined fundraising effort by the parishioners saved the historic church. Today it is the nucleus of Detroit's Mexican community and a catalyst for area redevelopment.

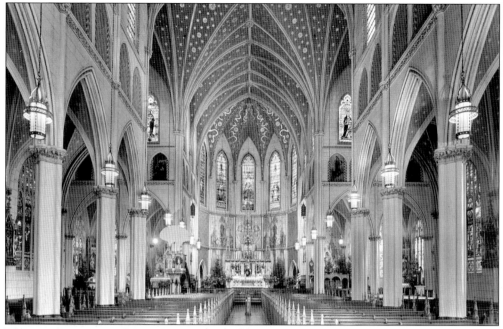

The ornate interior of Ste. Anne inspires both awe and reverence. It is always a favorite stop among the regularly scheduled local church tours sponsored by the Detroit Historical Museum. Buried in a crypt within the church are the remains of Ste. Anne's most famous pastor, Father Gabriel Richard.

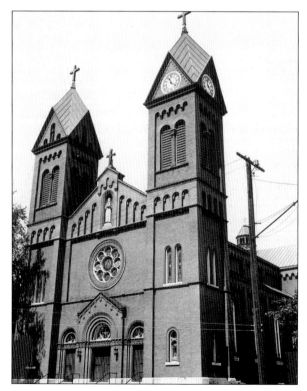

In 1857, German farmers living north of present downtown Detroit formed the core of the congregation for St. Anthony Parish. This Romanesque structure, located on Fields and Sheridan one block west of Gratiot, was designed by Donaldson and Meier and dedicated in October 1902. The church was completed for what today seems the paltry sum of $55,000. St. Anthony is now a mainstay for Detroit's African-American Catholics.

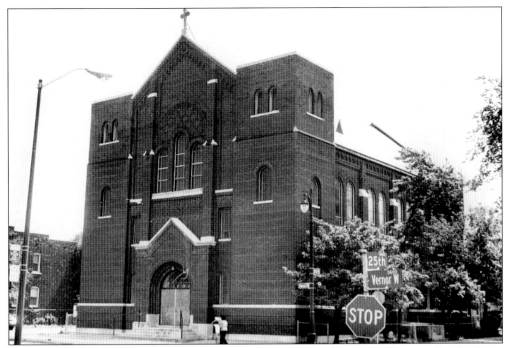

Located at the corner of 25th and West Vernor in southwestern Detroit, St. Anthony Lithuanian was founded in 1920 to serve the increasing numbers of Lithuanians moving into that part of the city seeking work in the area's heavy industries. To this day, the Mass schedule at St. Anthony is celebrated entirely in Lithuanian.

The X-shaped tape that reinforces the new windows is still visible as St. Brendan, located on Beaconsfield near the Detroit-Grosse Pointe border, nears completion in 1954. St. Brendan, a contemporary structure designed by architect Robert Wakely, was one of the last Catholic churches built within Detroit city limits.

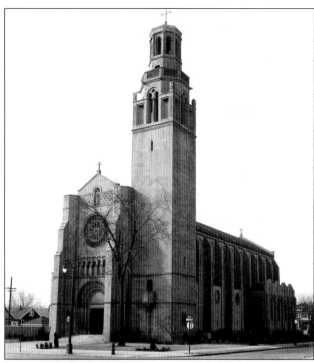

Even the Great Depression did not dampen the spirits of parishioners as Bishop Michael Gallagher dedicated the new church of St. Cecilia in May of 1931, a decade after the parish was founded. Italian architect Antonio DiNardo designed this striking example of classic Romanesque architecture. Today St. Cecilia, located on Stoepel just north of Grand River and Livernois, takes pride in having one of the finest high school athletic programs in Detroit.

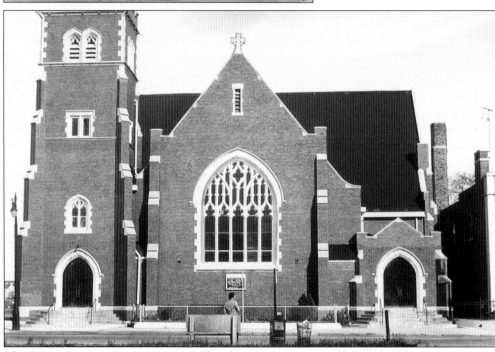

The former Brewster Congregational Church at West Warren and Trumbull, built in 1919, was purchased in 1926 by the Detroit Diocese and made the new home for St. Dominic. The parish was founded to alleviate the overcrowding at neighboring St. Leo to the west on Grand River. The Dominican Fathers had staffed the parish since its inception but withdrew in 2000 and administrative responsibilities returned to Archdiocesan priests.

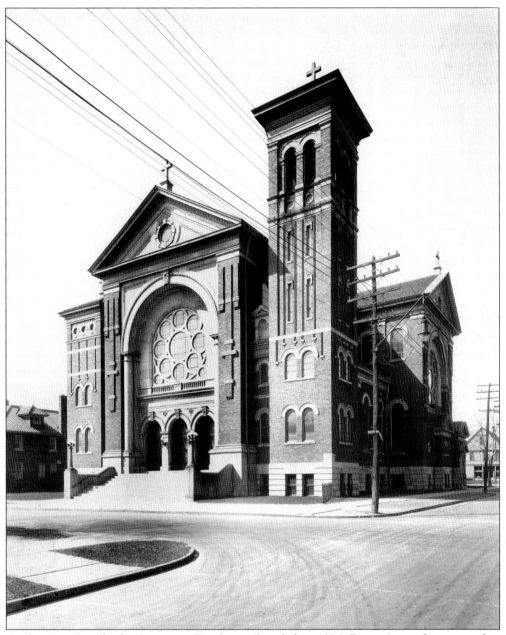

At the time St. Charles Borromeo Parish was founded in 1886, Detroit's population stood at just under 220,000. Among them was a sizeable group of Belgian and Dutch Catholics who, two years earlier, established Our Lady of Sorrows on the city's east side. As more Flemish immigrants came to Detroit and settled closer to Jefferson Avenue, even the relatively short trek to Our Lady of Sorrows became arduous during winter when snow-choked side streets became impassable. With Bishop Borgess' permission, St. Charles was founded for the Flemish nearer to Jefferson. The present church (actually the third version), on Baldwin and Townsend north of Jefferson, is a cruciform structure designed in 1918 by Peter Dederichs. It is done in an early Renaissance-Romanesque style, with the tower standing at 104 feet while the length from front to rear measures at 180 feet.

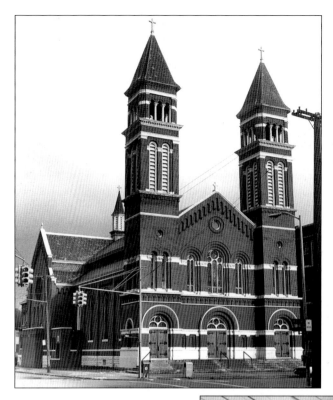

St. Elizabeth, founded in 1884, had a beginning that was nothing short of amusing. It was established exclusively for Germans, the founding pastor was Swedish, but the parish quickly filled with Poles when their own nearby church became overcrowded! Donaldson and Meier designed the present Romanesque Revival structure, located at the corner of McDougall and Canfield, east of Chene. Bishop John Foley dedicated the completed edifice in February 1892.

This richly detailed exterior belongs to the present St. Francis D'Assisi, located at Wesson and Buchanan on Detroit's west side. Founded in 1889, the parish served the Polish community in the area. Designed by Kastler and Hunter, the church reflects the Italian Renaissance style. St. Francis D'Assisi was solemnly dedicated on June 4, 1905 and today has the distinction of being the oldest surviving Polish parish in the city.

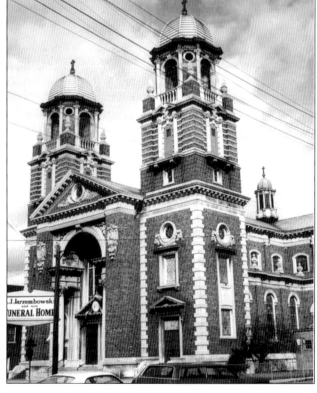

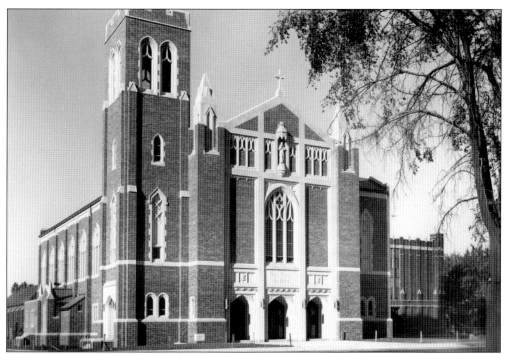

Burdened by a dwindling congregation and declining revenues, St. Francis de Sales, established in 1927 on Fenkell near Wyoming, devised a unique solution to rescue itself. The worship facilities were transferred to the smaller original church, once used as the school gym, while the larger, permanent Gothic structure shown here (built in 1952), was taken over by nearby Loyola High School and made into a gym for the all-male academy.

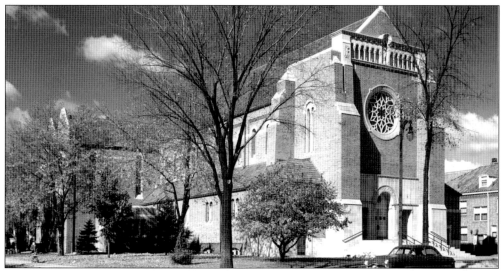

In 1923, the founding pastor of St. Gregory the Great, Fr. Frank Pokriefka, expressed his concern in a letter to Bishop Michael Gallagher that a new neighboring Jesuit parish (the present Gesu) was encroaching into his territory and urged the bishop to "insist they remain within their own domain." St. Gregory, on Dexter between Livernois and Linwood near the old St. Francis Home for Boys, has a seating capacity of 1,200.

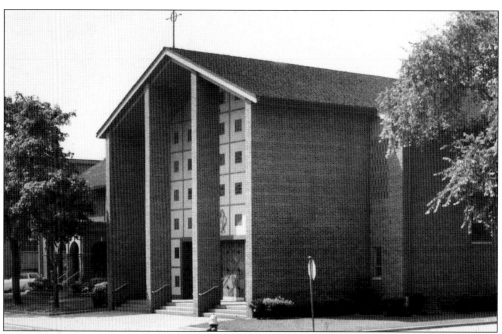

St. Gabriel, located on West Vernor north of I-75 in southwestern Detroit, began its existence in a neighborhood garage in 1915. The present church, shown here, was dedicated in 1955. At first the parish included French, Germans, and Italians but has since become home to the area's Mexicans.

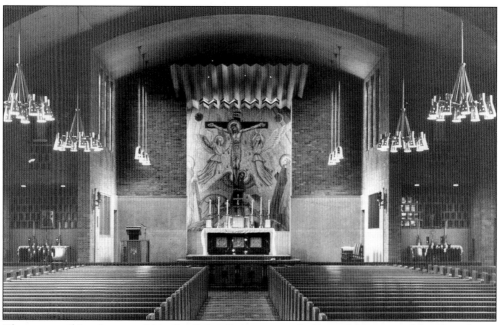

The most striking feature within St. Gabriel's interior is the beautiful mosaic of the Crucifixion behind the altar. Although designed in Detroit, the actual assembly of the mosaic took place in Italy at the hands of skilled artists and craftsmen. It measures nearly 20 feet high and contains an estimated one million tiles.

Architect Harry J. Rill designed the present St. Hedwig, on Junction just south of Michigan Avenue. Nearly 3,000 people packed the church for the solemn dedication ceremony on November 30, 1916. St. Hedwig was founded in 1903 to serve those Polish residents who could not conveniently travel to St. Francis D'Assisi on the northern side of Michigan Avenue.

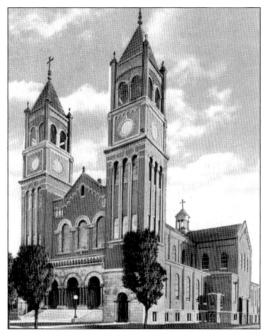

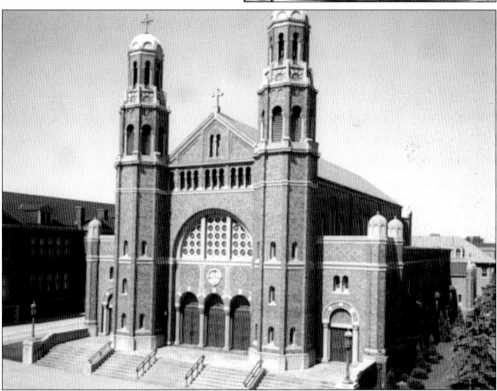

St. Hyacinth, located on Farnsworth and McDougall south of I-94, was one of the few Polish parishes to survive the continuous exodus of residents from the old Poletown area of Detroit. Founded in 1907, the present church shown here, designed by Donaldson and Meier, was dedicated in 1924.

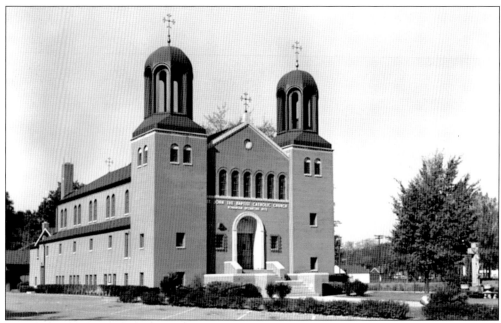

The firm of Diehl and Diehl was responsible for the present church of St. John the Baptist Romanian Byzantine Rite, located on Woodstock immediately west of Woodward and Eight Mile, in 1955. The church incorporates both Eastern and Western architectural styles, most notably the rounded domes atop each steeple that are characteristic of Byzantine designs.

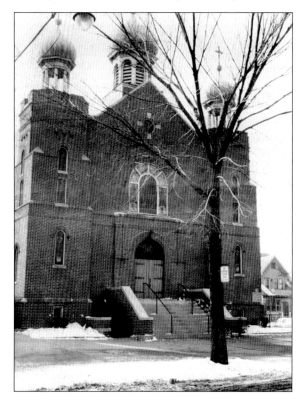

Detroit's first Ukrainian immigrants arrived in the early 20th century. Their mother church, St. John the Baptist, was founded in 1908 on Cicotte in the area of Michigan Avenue and Livernois. The parish relocated on Clippert in 1917 and built the church shown here. In June 2001, a fire broke out in the sacristy that threatened the church, but the damage was quickly contained and has since been repaired.

26

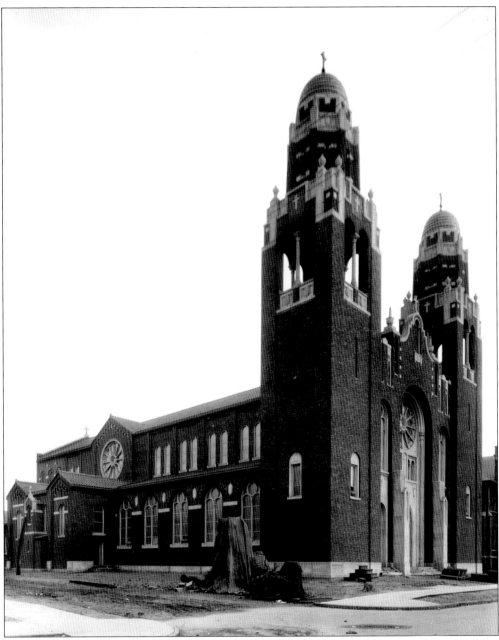

St. John Cantius, on Pulaski and Anson in southwest Detroit, was founded in 1902 to serve Poles living in the city's Delray section. Construction of the present Romanesque church began in 1923 and was completed two years later. In its heyday, that part of Delray was alive with the sights and sounds of playing children, "mom and pop" businesses and a host of foreign languages and cultures. Much has changed since then, yet despite the absence of any nearby residential neighborhood and St. John's unfortunate location among the most malodorous industries in Detroit, the parish has managed to stave off closing, thanks to a small but fiercely devoted congregation.

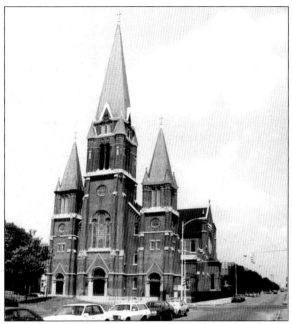

St. Josaphat, at East Canfield and what is now the I-75 service drive, was founded in 1889 to serve the growing numbers of Poles living on the western fringe of Poletown. This structure (the present church), which was designed by Kastler and Hunter, was dedicated in 1900 and is the only church in the city with three steeples. The center tower rises 200 feet while its smaller counterparts measure at 100 feet.

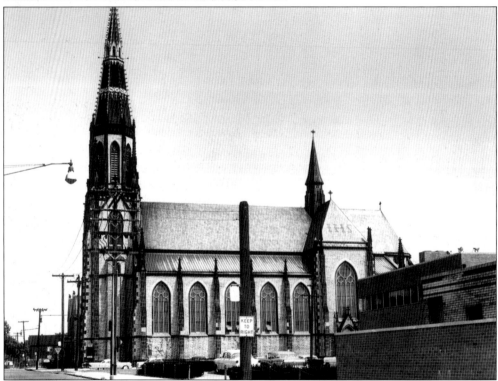

Detroit's Germans petitioned Bishop Peter Paul Lefevre for a new parish at the corner of Jay and Orleans (presently in the heart of the Eastern Market district) and in 1856, St. Joseph was established. Architect J.X. Himpler designed the historic building, consecrated by Bishop Caspar Borgess in 1873. Its stained glass windows, produced by the Friedrich Staffins Company of Detroit, are considered among the most beautiful in all of Michigan.

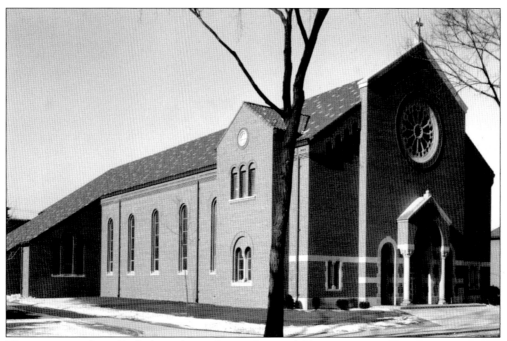

The property where St. Luke is located, on Ohio and Tireman west of Livernois, was once an apple orchard. Founded in 1927, St. Luke began its existence as did many other parishes, in a small storefront nearby until sufficient funds were raised to build a permanent structure. Ground was broken for the present church in 1958 and the completed edifice was dedicated by Archbishop John Dearden in December of 1959.

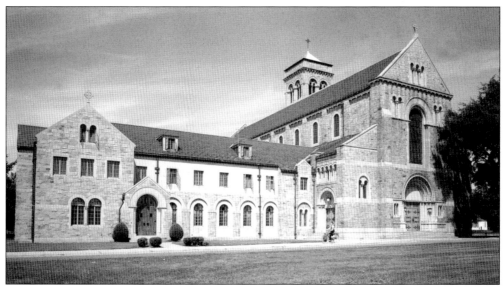

St. Mary of Redford, on Grand River between St. Mary's and Mansfield, attained legendary status in Archdiocesan history for having one of the largest congregations ever, numbering 5,000 families during its peak years in the 1950s. The task of designing the gray granite French Romanesque structure, completed in 1926, was initially offered to famed Detroit architect Albert Kahn, but he declined and recommended his equally acclaimed Boston colleague, Ralph Adams Cram.

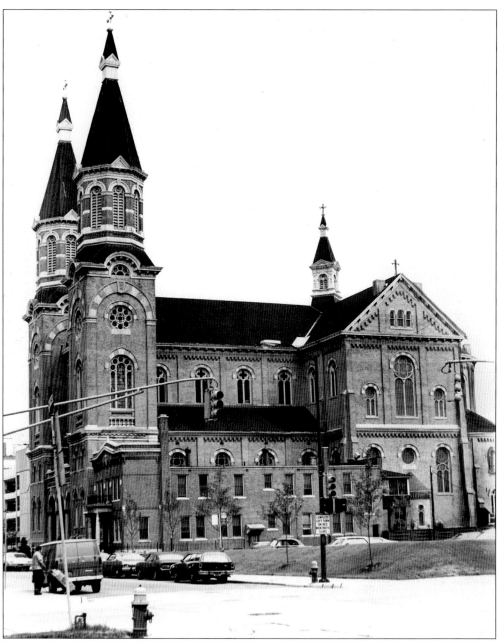

St. Mary, at the corner of Monroe and St. Antoine in the heart of Greektown, was the first German parish within Detroit city limits at the time it was founded in 1835. Designed by Peter Dederichs, the present church, completed in 1885, combines the best elements of Pisan Romanesque and Venetian Renaissance architecture. In 1911, St. Mary housed St. Peter Claver, the first mission for Detroit's African-American Catholics. The mission thrived at St. Mary until it was transferred to nearby Sacred Heart in 1938. Today, St. Mary is as much a tourist attraction as are the restaurants and retail shops in Greektown.

The Detroit area has the largest concentration of Arabic people within the United States. The oldest parish established exclusively for Arabic Catholics is St. Maron, founded in 1915 on Kercheval on the city's lower east side. St. Maron's congregation is mainly of Lebanese descent, including some Syrians. Historically, the Maronite Rite, as it is called, traces its allegiance with the Roman Catholic Church back to the 12th century.

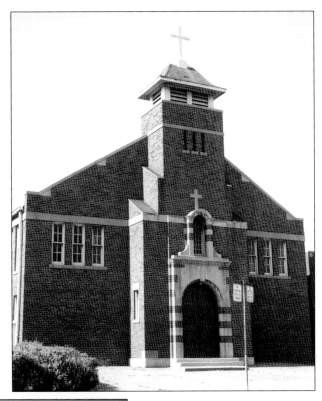

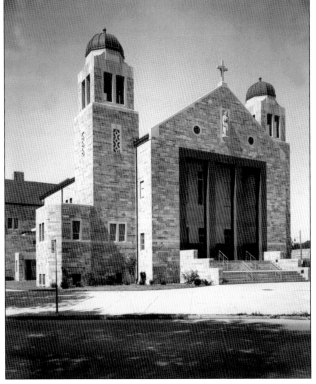

At the time St. Matthew was founded in 1927, there were only five homes in the area of what is now I-94 and Cadieux. The present church, shown here, located at Whittier and Harper, was designed by Donaldson and Meier and dedicated in 1955. The columns and horizontal beam atop the main entrance are made of rose red granite from Sweden.

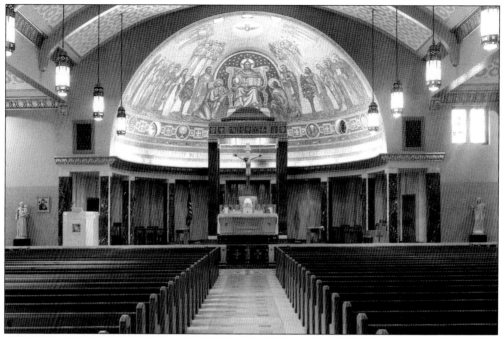

The mosaic that adorns the dome above the altar at St. Matthew overwhelms visitors with its beauty and intricacy of detail. It is considered one of the largest such mosaics in the United States. Designed by Andrew Maglia, the 2,300 square foot work of art depicts Christ and the Twelve Apostles, along with a host of other figures. It contains an estimated 1,500,000 tiles.

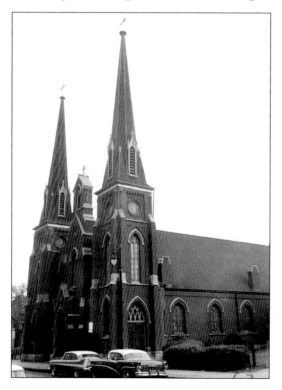

St. Patrick, founded in 1862 at John R and Adelaide, served Irish residents north of what is now Comerica Park. The early Gothic structure, designed by Jordan and Anderson, drew criticism from those who believed the ornate church was an extravagance. Founding pastor James Hennessey countered by saying his church "will someday be the Cathedral." His prophetic words were realized nearly three decades later when Bishop John Foley declared St. Patrick the diocesan cathedral in 1890.

SS. Peter and Paul Jesuit (1844), on Jefferson across from General Motors World Headquarters, served as the diocesan cathedral until 1877 when it was turned over to the Jesuit community. It is described in the Michigan Historic Register as "one of the oldest original structures" in the city. An ill-conceived whitewash of the exterior, shown here, has since been removed and the building restored to a natural brick finish.

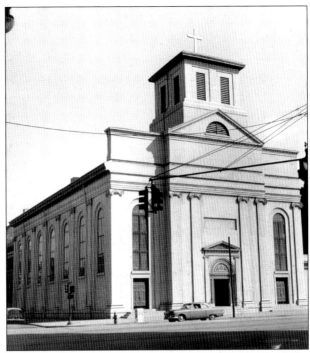

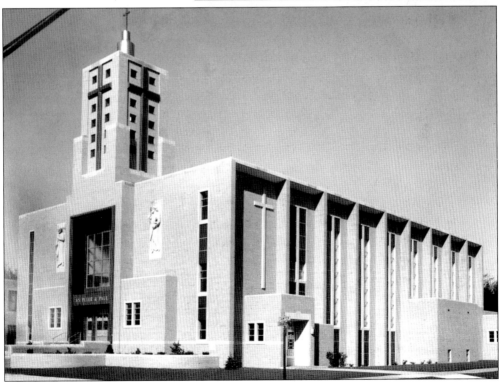

SS. Peter and Paul was established in 1923 on Grandville near the Detroit-Dearborn boundary just north of West Warren. To this day, it serves the Polish community on the city's far west side. The present church, designed by Donaldson and Meier, was dedicated in December 1959.

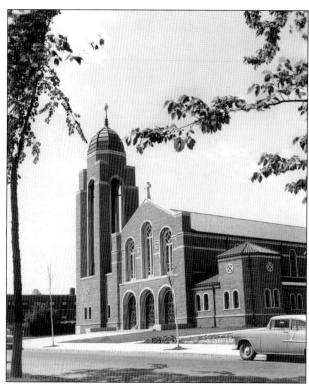

St. Raymond, founded in July 1941 on Joann south of Eight Mile Road, was one of the first new parishes established by Archbishop Edward Mooney following his appointment to the Detroit Archdiocese in 1937 and one of the last opened in the city prior to World War II. The present Romanesque structure was used for the first time on Easter Sunday, 1957.

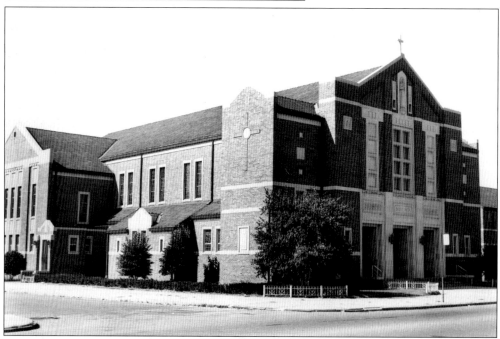

St. Rita's first congregation in 1924 was comprised of families who had previously attended either St. James in Ferndale to the north or St. Benedict in Highland Park to the south. The present church, situated on East State Fair near the I-75-Eight Mile junction, is a modified Romanesque style designed by Donaldson and Meier and was dedicated in December of 1954.

Architect Robert Svoboda designed this simple contemporary edifice for St. Thomas Aquinas Parish in 1956. Located on Evergreen near Ford Road on Detroit's far west side, St. Thomas has the distinction of being the last Catholic church built within city limits.

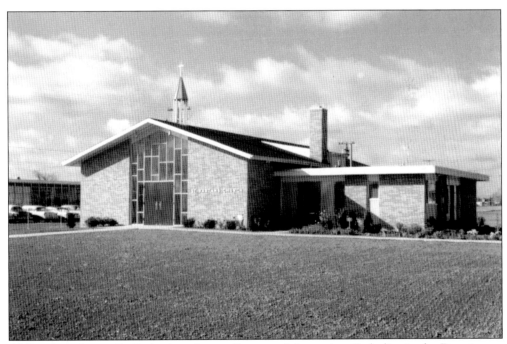

Although traditionally Orthodox, the small group of Armenian Catholics in the Detroit area attend St. Vartan on Greenfield near Eight Mile on the city's northwest side. Architect Joseph Cyr designed this attractive contemporary structure, dedicated in 1958.

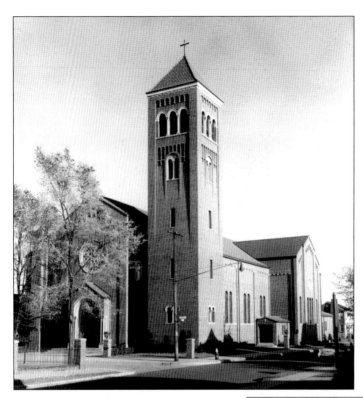

About 200 Polish families living in the Six Mile-Mound area petitioned Bishop Michael Gallagher in 1925 for a parish of their own. The bishop gave his blessing to the project and Transfiguration was established that year. The present church, shown here, is of a Romanesque design and was completed in 1950. Interestingly, the church is located on Simon K Street, named after parish founder Fr. Simon Kilar.

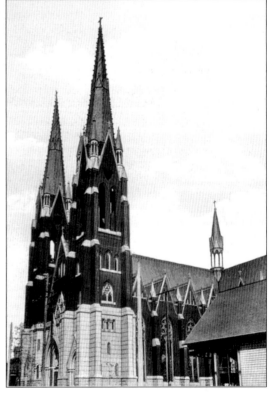

Despite its controversial origins, Sweetest Heart of Mary, at Russell and Canfield in Poletown, became one of the premier parishes in Detroit. Its maverick founder, Fr. Dominic Kolasinski, was banished from the diocese by Bishop Caspar Borgess for a variety of alleged transgressions that later proved false. Kolasinski returned in defiance of the bishop and marshaled his friends and supporters to build this impressive edifice independent of the bishop's authority.

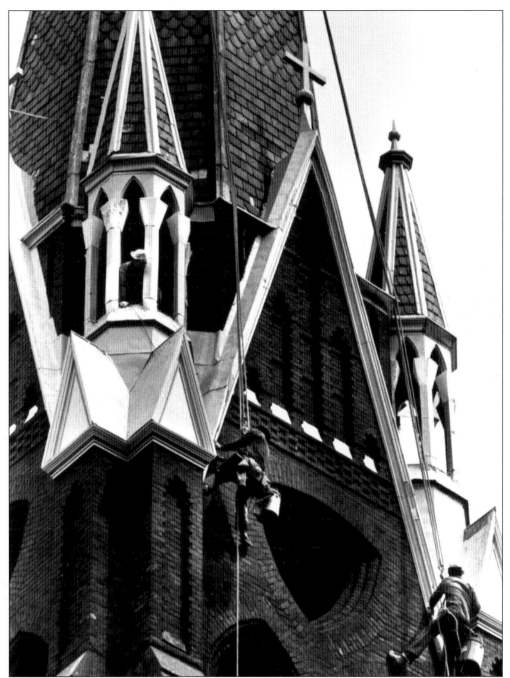

Workers move gingerly along the highest point of Sweetest Heart of Mary to do the necessary maintenance and repairs to the masonry and roof. This photo provides a rare close-up view of the intricate, sharply-defined details integral to 19th century architecture, features noticeably absent from contemporary designs. The church, dating to 1890 and designed by the local firm of Spier and Rohn, is one of the finest examples of Late Victorian Gothic architecture in the city. Sweetest Heart is listed on the Michigan historic register and draws numerous visitors annually. The twin spires tower at 217 feet.

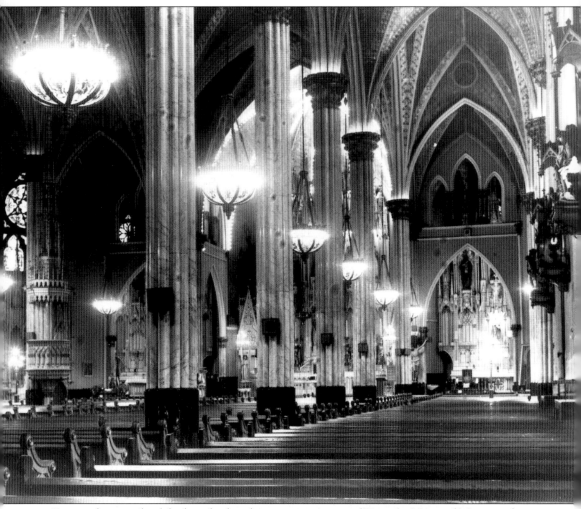

Even a photograph of the breathtakingly gorgeous interior of Sweetest Heart of Mary can leave a lasting impression on you, let alone seeing it in person. The vaulted ceilings reach a height of 76 feet. In addition to the columns shown, there are two rows of ten-inch wrought iron columns that aid in supporting the roof. Attached to the face of the column at far left is the pulpit from which the parish's iconoclastic, legendary pastor, Fr. Dominic Kolasinski, issued his Vatican-mandated recantation in 1894 to prevent himself and his congregation from being excommunicated.

Two

THE SUBURBS
OLD TRADITIONS,
NEW VISIONS

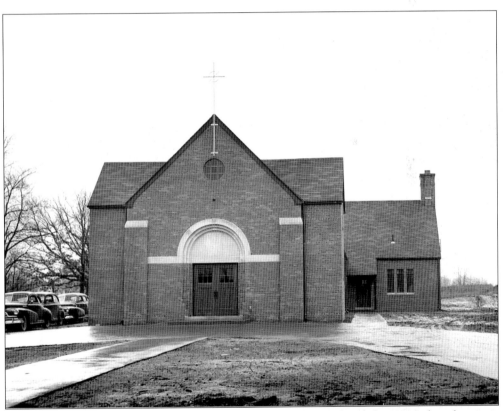

Sacred Heart, on Adams Road south of M-59 in Auburn Hills, was founded in 1946 when the owner of the Detroit Tigers, Walter Briggs, deeded 23 acres to the Archdiocese for one dollar. The firm of Herman and Simons was selected to construct the chapel/church hall. At first, Sacred Heart was a mission of St. Vincent de Paul in Pontiac. It then became an independent parish in 1959.

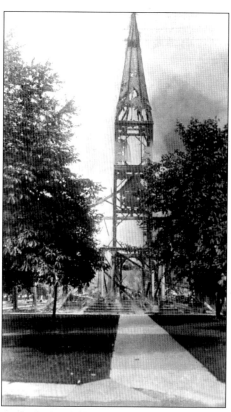

The combination of candles and a wooden structure often proves lethal. Here, the steeple of Immaculate Conception in Anchorville nears collapse in August 1917 as flames destroy the church that dated to 1892. According to reports, the fire began in the basement and spread quickly to the upper level.

HOLY NAME CHURCH, BIRMINGHAM, MICH.

Holy Name in Birmingham began its existence in 1918 as the northern extension of St. Mary in Royal Oak. The first church resembled a Spanish-styled mission in the old American West, measuring 80 feet by 30 feet. It was dedicated in April of 1922.

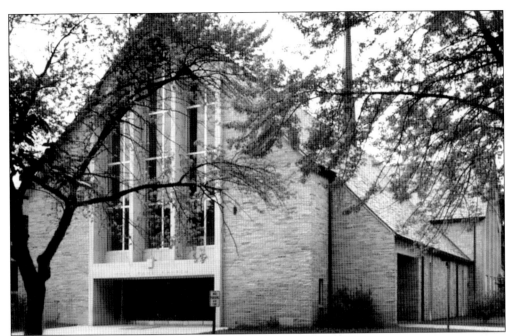

As Holy Name grew, the firm of Diehl and Diehl designed the current church with its seating capacity of about 900. Cardinal Edward Mooney dedicated the new structure in 1955. The parish is located at Woodland and Harmon between West Maple and Quarton in Birmingham.

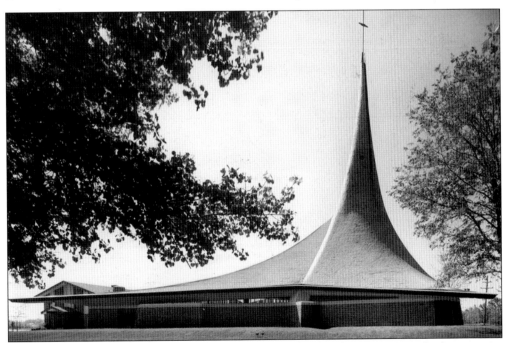

The most striking feature of St. Regis in Bloomfield Hills is the upswept steeple that conveys an almost ethereal quality, rising gracefully to the heavens. The local firm of Brown and Brown was responsible for this contemporary design, dedicated in 1968 by Archbishop John Dearden. The parish is located on Lincoln just east of Lahser.

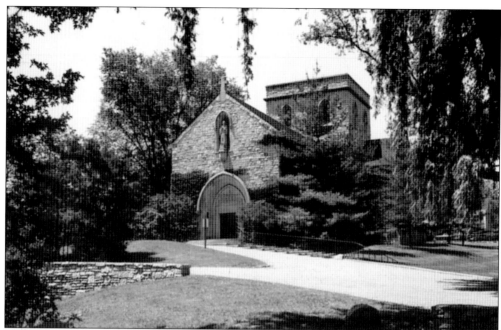

This Norman Gothic cruciform structure was the first church for St. Hugo, on Opdyke Road in Bloomfield Hills. Established in 1930, St. Hugo is the only Catholic church in the country to be funded entirely by private donations. The McManus family commissioned Arthur Des Rosiers as the architect. Although it has since been supplanted by a larger, contemporary building dedicated in 1989, the former church still exists on the parish grounds.

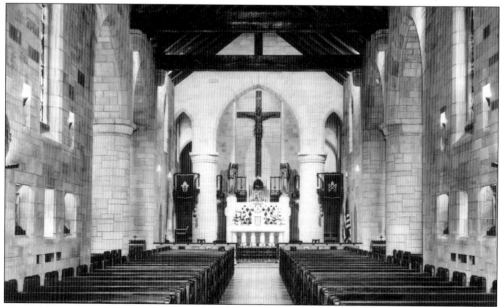

The interior of the old St. Hugo reflects the classic style prevalent in medieval European church architecture. Beneath the worship area is a crypt where members of the McManus family are interred, a practice made possible by special permission of the Vatican. St. Hugo is the only Catholic church in the United States where such an interior crypt exists for laypersons.

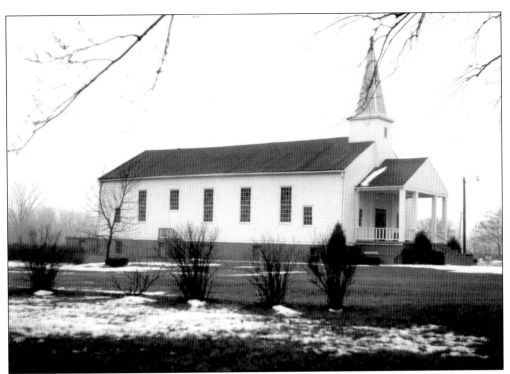

This modest yet appealing structure is the church of St. Irene in the rapidly growing rural community of Dundee in Monroe County. St. Irene was founded in October 1944 as a mission of St. Joseph in Ida and then became an independent parish in June 1964.

In 1952, architect Robert Svoboda was chosen to design the church for the new parish of St. Basil in Eastpointe (then East Detroit) on Schroeder north of Nine Mile Road. Until the structure was completed in 1953, services were held in a leased store nearby for $75 a month. The church underwent extensive renovations and was rededicated in April of 1997.

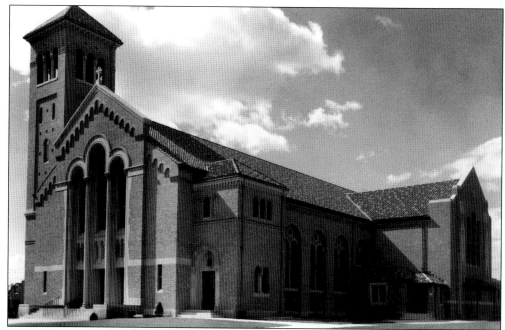

St. Veronica is the oldest parish in Eastpointe (1926). The city was once known as Halfway, since it represented the midpoint between downtown Detroit and Mt. Clemens. After World War II, St. Veronica became one of the largest parishes in the Archdiocese, requiring a more spacious church. The present edifice, on Universal east of Gratiot and Eight Mile, was designed by McGrath and Dohmen and dedicated in 1958.

St. Francis Xavier in Ecorse is one of the older parishes in the Archdiocese. Founded in 1848 by French settlers, the parish is currently located on West Jefferson near Outer Drive. The present church, shown here, dedicated in 1953, is essentially a modernized version of a California mission. A sizeable percentage of the congregation today is of Mexican descent.

When Our Lady of Mt. Carmel in Emmett (St. Clair County) was founded in 1853, the area consisted of a few scattered farms and wilderness crossed by Indian trails. The Gothic-influenced structure shown here, designed by Harry J. Rill, had imported stained glass windows and a huge bell cast in Belgium. Dedicated in 1897, this church was destroyed by fire in October of 1966, to be replaced by the current edifice.

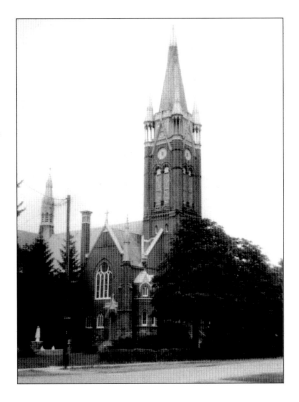

Believe it or not, St. James in Ferndale began its existence in 1919 in a refurbished chicken coop! Needless to say, the present structure represents a vast improvement. Situated on the corner of Pearson and southbound Woodward north of Eight Mile, St. James was designed by Donaldson and Meier and dedicated in 1950.

Gibraltar in southern Wayne County is the home of St. Victor Parish, located on Navarre between West Jefferson and the Detroit River. St. Victor began its existence in October 1957 as a mission of St. Timothy in neighboring Trenton, then became an independent parish in June 1963. The firm of McGrath and Dohmen designed this structure in 1961.

Having outgrown its original stone chapel dating to 1916, Sacred Heart Parish on Grosse Ile south of Detroit began a fundraising drive to build a more spacious edifice. The firm of Diehl and Diehl designed this modern structure, dedicated in 1965. As far back as the 1870s, visiting priests from the mainland communities of Trenton, Wyandotte, Ecorse, and Rockwood served Sacred Heart before it became an independent parish in 1920.

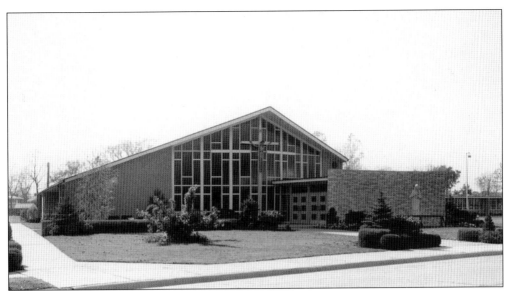

When Cardinal Edward Mooney sent Fr. Ralph Barton to the vicinity of Fairford and Morningside in Grosse Pointe Woods to establish a new parish in 1954, the designated parcel of land, inaccessible by car, was littered with the ruins of an old barn and silo. Today, Our Lady Star of the Sea is in one of the more beautiful settings near Lake St. Clair. The church was dedicated in 1955.

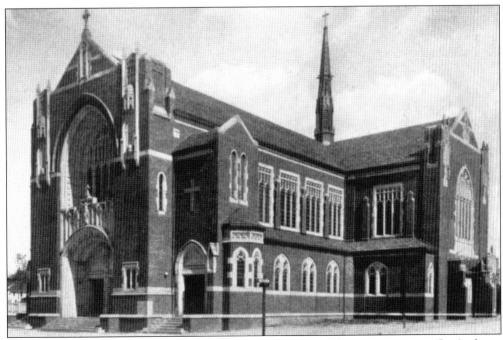

Like a number of parishes on Detroit's lower east side, most of the congregation at St. Ambrose consisted of automobile and other industrial workers who labored in the numerous factories in that area. St. Ambrose, founded in 1916, is located in Grosse Pointe Park on Hampton between Wayburn and Alter Road, one block north of Jefferson. The church shown here, designed by Donaldson and Meier, was completed in 1926.

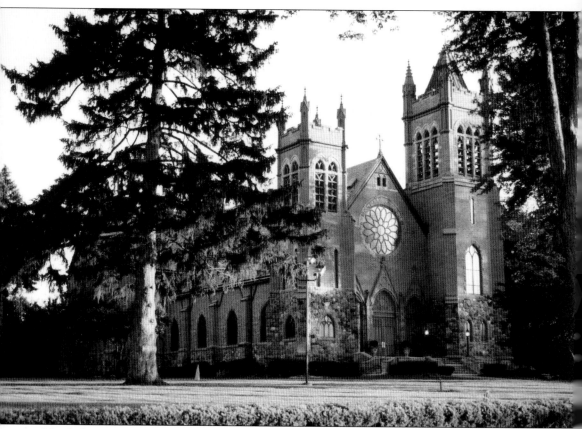

Nestled picturesquely on the shores of Lake St. Clair, St. Paul on Lakeshore Boulevard in Grosse Pointe traces its origins to French settlers in early Detroit who tilled their deep, rectangular "ribbon" farms that stretched along the riverfront. Although St. Paul's official founding date is recognized as 1834, organized Catholic worship in that vicinity can be traced as far back as 1825. St. Paul served as a home base for missionaries who traveled either on horseback or by canoe to minister to the scattered settlements around the Lake St. Clair basin. Harry J. Rill designed the present French Gothic church during the pastorate of Fr. John Elsen. Ironically, the first funeral service held at the new church was that of Fr. Elsen, who died in 1899 and was buried in the cemetery adjacent to the church.

The Augustinian Fathers have administered St. Clare of Montefalco in Grosse Pointe Park since it was founded in 1926 at Whittier and Charlevoix near Mack. The present church, designed by Diehl and Diehl, was dedicated in 1953. Fittingly, the first infant baptized in the new church was the architects' niece, Mary Kathryn Diehl.

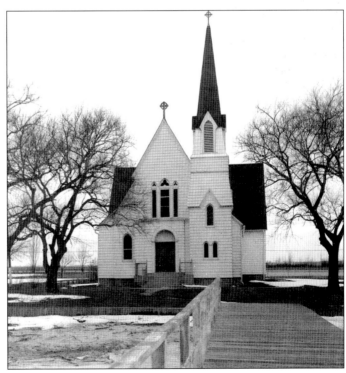

The idyllic Harsen's Island, a popular summer hideaway on the St. Clair River, is the home of St. Mark. Established in 1897 as a mission of St. Catherine in Algonac, St. Mark's congregation often arrived for Sunday services by boat! A 1935 plan to widen the river's south channel would have closed St. Mark, but the island's property owners protested and the idea was scrapped. St. Mark became independent in 1974.

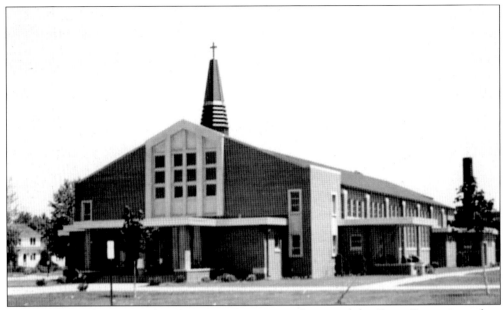

St. Mary Magdalen in Hazel Park traces its origins to the eve of the Great Depression when in February 1929, a vacant storefront was utilized for the first services of the fledgling parish. Archdiocesan priests staffed St. Mary Magdalen until April 1977 when the Capuchin friars assumed that responsibility. The present church, of a modern Romanesque design at the corner of John R and Woodward Heights, was dedicated in 1958.

Father Maurice Walsh, working together with architect Arthur Des Rosiers, designed this attractive church for St. Rita in Holly. The stones were gathered from nearby farm fields and hauled to the construction site by horse-drawn wagons. Although the structure itself was dedicated in 1925, the interior remained largely unfinished until 1950. St. Rita began its existence as a mission of St John in neighboring Fenton.

Holy Family, on Annapolis between Middlebelt and Inkster roads, was established in 1945 to serve African-American Catholics who lived in the Inkster area and worked in the defense plants in western Wayne and Washtenaw counties. Since its inception, Holy Family has been faithfully served by the Holy Ghost Fathers. The present church, pictured here, was constructed in 1963 under the supervision of pastor Fr. Sylvester Fusan.

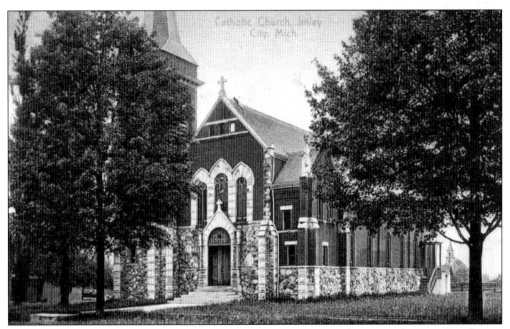

Imlay City in Lapeer County is home to Sacred Heart, presently on Maple Vista Road, west of M-53. Sacred Heart began its existence as a mission of Immaculate Conception in Lapeer in 1874, but the Catholic presence in the Imlay City area dates as far back as 1852. The first permanent church, shown here, was built sometime in the late 1890s.

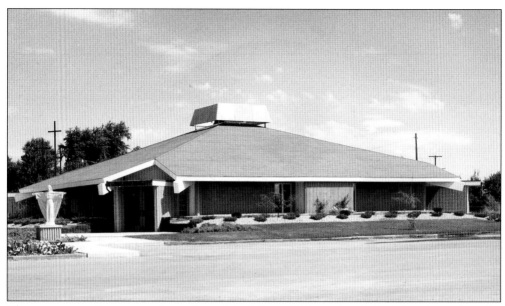

Three-quarters of a century later, the original Sacred Heart church had deteriorated to the point where it required a complete reconstruction. Due to the cost involved, it was deemed more practical to simply build a new church. The Lansing firm of Mayotte, Crouse and D'Haene was responsible for this aesthetically pleasing structure designed to blend in harmoniously with its surroundings. It was dedicated in December 1972.

Immaculate Conception in Lapeer is recognized as having been founded in 1853, although there was a Catholic presence in that area as far back as 1844. This beautiful stone church was dedicated in September of 1901 and remains in use to this day. Parishioners hauled the stones from surrounding fields and a local non-Catholic family made a generous gift to the parish in the form of a 10-bell carillon.

The tremendous number of returning servicemen following World War II provided the necessary impetus to establish new parishes such as Christ the Good Shepherd in the downriver community of Lincoln Park. Founded in 1947, Christ the Good Shepherd grew from only 100 families to over 2,000 in less than a decade. A newer, larger church, on Riverbank and Howard east of Dix, was dedicated in September of 1955.

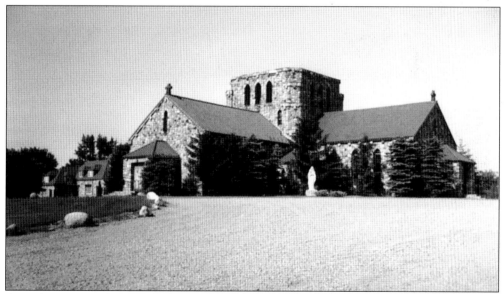

According to popular accounts, Fr. Joseph Ording photographed a 17th century Normandy-styled church while on vacation in northeastern Italy, and upon his return, handed the picture to architect Arthur Des Rosiers and requested a similar church for his parish of St. Joseph in Lake Orion. The builder, Dennis O'Connor, completed the edifice for $56,000. The first service held in the new church was Christmas Midnight Mass in 1940.

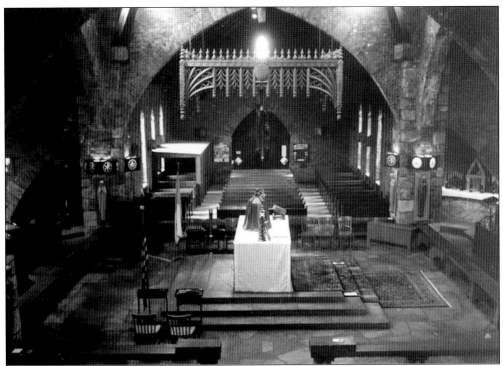

The rustic stone interior of St. Joseph in Lake Orion, with its vaulted arches, immediately transports you back to medieval Europe during the age of solemn ecclesiastical celebrations filled with pomp and splendor. To accommodate an ever-growing congregation, the church underwent an extensive renovation and expansion highlighted by a rededication Mass in 1998.

Archbishop John Dearden gave his approval to establish a new parish in the fast-growing suburb of Livonia in June 1963. The first church for St. Aidan was this modest, functional structure designed by Donaldson and Meier, located on Farmington Road between Six and Seven Mile. St. Aidan shares the same name of the boyhood parish of President John F. Kennedy in Brookline, Massachusetts.

Architect Charles D. Hannan was called upon to design this first church for St. Edith in Livonia, dedicated by Archbishop John Dearden on Christmas Eve, 1962. St. Edith's fortuitous location on Newburgh Road near the junction of major thoroughfares (I-275 and I-96) has contributed mightily to its growth, requiring a newer, larger church built in 1979.

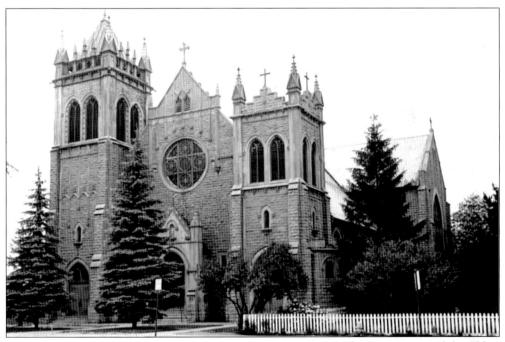

Located on the banks of the St. Clair River in Marine City, Holy Cross is one of the oldest parishes in the Archdiocese and dates to 1825. Builder Michael Sicken, having submitted the lowest bid at just over $33,000, was awarded the contract for the construction of the present Gothic church in 1903. When cost overruns exceeded the original bid by $12,000, Mr. Sicken paid them out of his own pocket.

Marysville in St. Clair County became the home for St. Christopher Parish in 1936. The combination church and school building, shown here, was the second church, dedicated in 1953. Steady growth of the congregation from a mere 60 families at the outset to over 700 today required the construction of a newer, larger church, dedicated in 1986.

When Catholics in Maybee (Monroe County) wearied of the taxing journey every Sunday to St. Patrick in Stony Creek, they petitioned Bishop John Foley for their own church. In response, St. Joseph was founded. Matthew Krutcher of Bay City was the general contractor for this classic example of a "country" church with its familiar, heartwarming style. The edifice shown here, dedicated in 1889, is still in use today.

Founded in 1926, St. Mary Magdalen, on Wood near I-94 and Outer Drive in Melvindale, initially encompassed a territory that included Allen Park, Taylor, and portions of Dearborn, Lincoln Park, and southwestern Detroit. Architect Charles Hannan designed this structure, the present church, dedicated in November of 1955. St. Mary Magdalen opened the first parish credit union in Michigan in 1930 to assist its members suffering the consequences of the Great Depression.

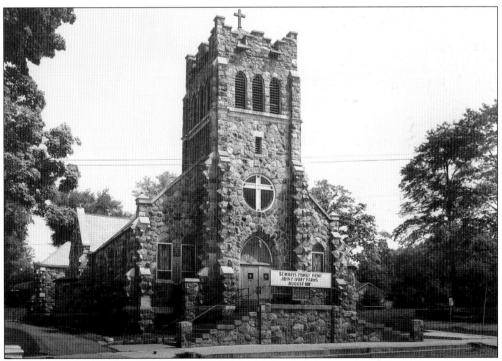

The site for St. Mary in Milford, founded in 1890, was once nicknamed "Catholic Hill." Architect Harry J. Rill originally designed this structure with A.G. Kuehnle acting as general contractor. Before the work was completed, however, Kuehnle went bankrupt. Donaldson and Meier finished the task for $16,000. The church shown here was dedicated in July of 1907. A more spacious, modern church was completed in 1976.

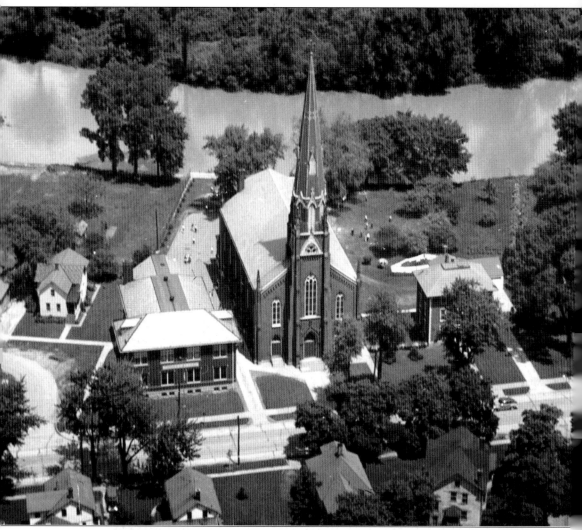

Feeling outnumbered by their French counterparts, German farmers in Monroe petitioned Bishop Peter Paul Lefevere for a church of their own in 1852. The bishop granted his approval and St. Michael was founded. According to the sesquicentennial history of the parish published in 2002, parishioners purchased the building plans for the cathedral at Fort Wayne, Indiana, for $100 and used them as the basis for St. Michael. This aerial shot of its physical plant perfectly captures St. Michael's tranquil setting with the Raisin River meandering in the background. Construction of the Gothic-styled structure with a seating capacity of 1200 was completed in just over a year and dedicated in October 1867. The impressive spire rises to a height of 160 feet.

St. John Church in Monroe
was dedicated in 1873, but
tragically, a fire caused by an
overheated furnace in January
of 1892 destroyed much of the
interior before the flames were
extinguished. With renewed
determination, the congregation
set about the task of rebuilding
the interior and the salvaged
edifice, with a shorter steeple,
was rededicated in October
that same year. With continued
modernizations, this structure
remains in use to this day.

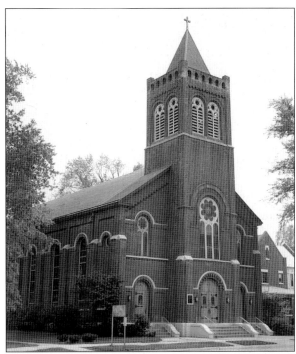

St. Mary (formerly Ste. Antoine) in Monroe is the second oldest parish in the Archdiocese, dating to 1788. The view of the church shown here gives evidence of the many revisions to the building over the years, reflecting a long history. The front half of the edifice (actually the third church) dates to 1839 while the seemingly incongruous back portion, noticeably higher than the front, was added in 1903.

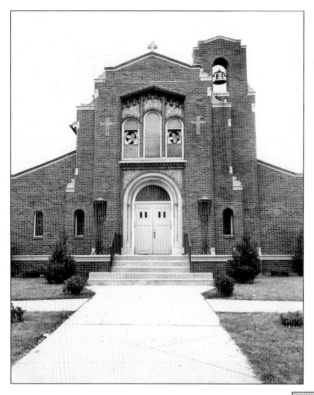

Unknown to many people is the fact that southwestern Wayne County is home to a sizeable population of Poles. St. Stephen, on Huron River Drive in New Boston, was founded in 1874 to serve them. The present church, designed by Arthur Des Rosiers, was dedicated in October of 1923. Local Polish farmers used their own horses to dig out the basement and haul building materials to hold down costs.

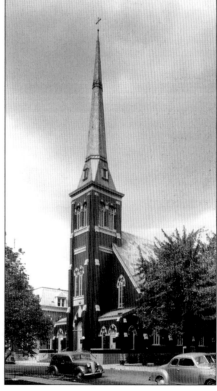

St. Peter, founded in 1843, was the first Catholic church in Mt. Clemens. The structure shown here, built during the pastorate of Fr. Charles Ryckaert, was dedicated in November of 1883. Regrettably, the church was destroyed by fire in September 1957 when a workman's gas torch accidentally ignited the woodwork. Accounts of the tragedy tell how neighboring pastors of different denominations ran into the burning building to assist in rescuing sacred objects.

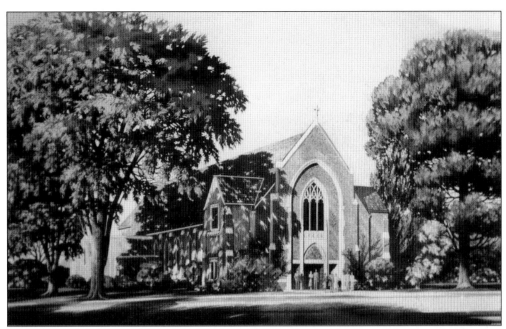

Despite the heartrending loss of their historic church, the parishioners of St. Peter, led by their pastor, Fr. Paul Heenan, set about the task of rebuilding. The local Jewel Theater served as a temporary site for services while the firm of McGrath and Dohmen designed this new edifice that deftly combines the best features of traditional and contemporary architecture. The church was dedicated in December of 1960.

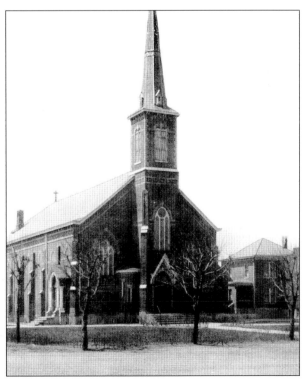

In 1839, French settlers erected a chapel in an area of Monroe County called "Riviere aux Cygnes" (Swan Creek), now known as Newport. Within five years, the chapel became the parish of St. Charles located today on Swan Creek Road. The third church, shown here, was completed in 1886 and with regular upgrading of its mechanicals and fixtures, continues to this day to serve its congregation of over 700 families.

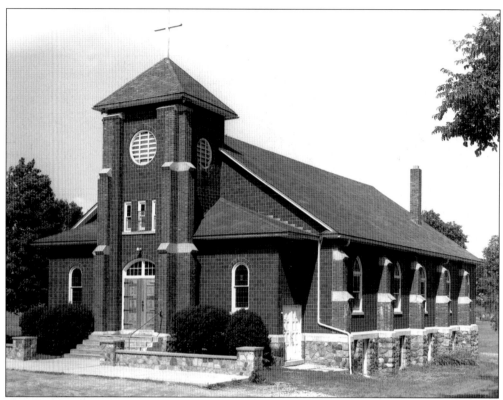

St. Mary Burnside in North Branch in Lapeer County began its existence in 1855 in a log cabin to serve the area's farmers. A second church was built in 1877, lasting until 1929 when it was destroyed by fire. The third church, shown here, has served its congregation since 1930. Originally, St. Mary was located in the town of Burnside but the U.S. Post Office has since re-designated its address as North Branch.

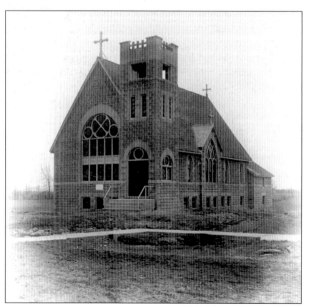

In 1906, Theodore Heenan purchased this Episcopalian church at the corner of Sherman and Banker streets in North Branch, then donated it to the diocese for the new mission of SS. Peter and Paul in May of 1907. Initially attached to Sacred Heart in Brown City, SS. Peter and Paul attained independent status in 1913. This first structure served the congregation until 1979 when a new church was built.

In an attempt to preserve the idyllic atmosphere of Orchard Lake in Oakland County, the village commission hurriedly passed a zoning ordinance in 1943 that would have prevented Our Lady of Refuge from constructing a new church. The Archdiocese sued and, after a lengthy litigation process, emerged victorious. Herman and Simons designed this combination church/school building, dedicated in May of 1953. Since then, a larger, modern church was built in 1976.

Partially obscured by its own wooded landscaping in this photo, St. Joseph on South Boulevard east of Orchard Lake Road in Pontiac, was founded in 1924 to serve the small Polish community in that area. Never a large parish, St. Joseph was threatened by closure on several occasions but survived through a variety of innovative programs and ministries over the years that included the establishment of a neighborhood health clinic.

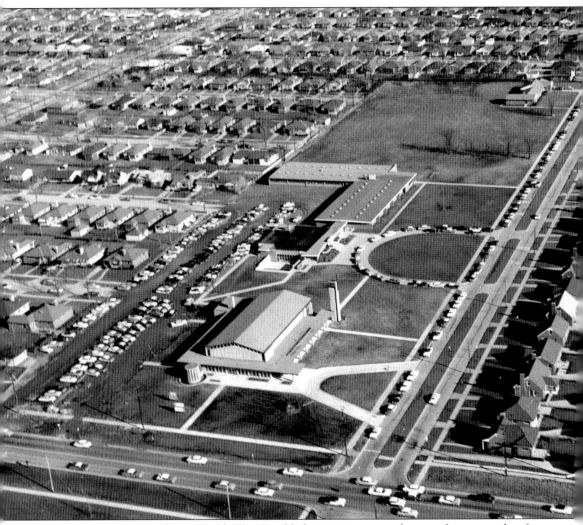

Returning veterans from World War II added momentum to the population exodus from America's major cities that was already underway during the post-war years. Across the country, new suburbs were springing up as residents sought to escape older, congested urban areas. This aerial view of Oak Park gives testimony to that trend, which in turn gave rise to new parishes. Our Lady of Fatima, on Oak Park Boulevard north of the intersection of Nine Mile and Coolidge, was founded in 1950 to serve the growing numbers of Catholics settling outside Detroit. Fire consumed the temporary church in 1956 but rather than rebuild the temporary structure, pastor Fr. Boleslaus Parzych requested permission from Cardinal Edward Mooney to proceed with construction of a new permanent church. The Cardinal gave his blessing and architect Robert Svoboda created this distinctive edifice, dedicated in 1958.

Since it was founded in 1920, Our Lady of Good Counsel in Plymouth seemed destined to relocate regularly. The parish initially was situated at Union and Dodge streets, then in 1949, moved to William and Arthur where architect Charles Hannan designed the second worship facility, shown here. The congregation remained at that address until 1966 when it moved yet again to Penniman and Arthur.

Since the late 1980s, population growth in western Wayne County has been explosive, perhaps nowhere more so than in Plymouth. Its "small town" ambience is an irresistible lure for newcomers. Consequently, the congregation at Our Lady of Good Counsel has grown to 2,700 families, requiring yet another relocation for a much larger church. This modern edifice at North Territorial and Beck roads, shown here nearing completion, was dedicated in September 2000.

The first Catholic church in Pontiac, dating to 1851, was St. Vincent de Paul. This structure, built in 1885, still serves the congregation to this day. To the immediate right of the church is the priest's rectory. Today St. Vincent has become the nucleus for the Hispanic community in Pontiac.

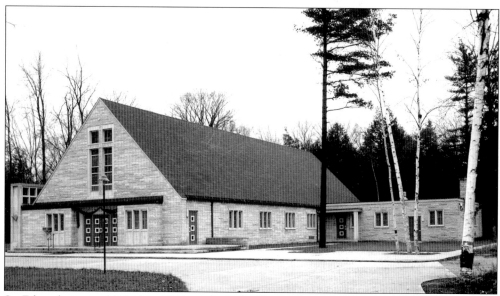

St. Edward was established in 1954 on the Lake Huron shore in Lakeport and founding pastor Fr. John Hogan wasted no time in having a permanent church built. The result was this unpretentious, appealing brick edifice designed by Charles Valentine, dedicated in 1955. St. Edward's ministry includes services and programs geared especially for the Mexicans in the Port Huron area who toil on the numerous farms in Michigan's thumb region.

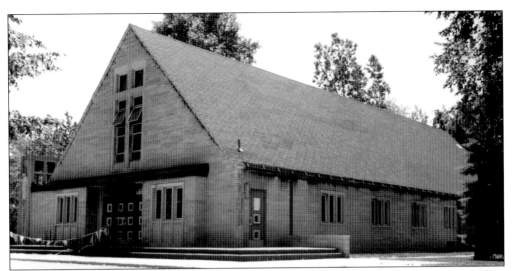

Any pastor will tell you his worst nightmare is that of a fire at his parish. In April of 1984, St. Edward experienced such a tragedy when fire gutted the church interior (charring can be seen above the main entrance and just beneath the roofline along the side). Despite the extensive damage, enough of the structure remained for it to be salvaged and, after considerable effort, rededicated in October of 1985.

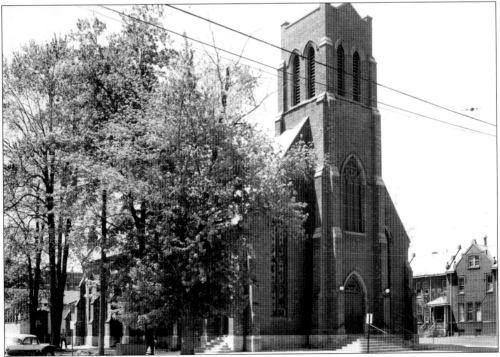

St. Stephen, the oldest parish in Port Huron, dates back to 1850. This Gothic structure is the second church, constructed in 1868. Sketches of the parish from that time indicate that originally, a steeple was to crown the building. Proving too costly, the idea was scrapped. The church was completed for $30,000, a considerable sum of money then. The building was demolished in the mid-1960s and replaced with a modern edifice.

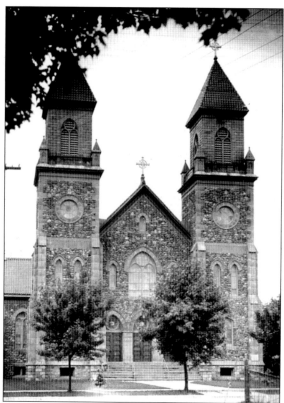

Established to serve German farmers in western St. Clair County, St. Augustine in Richmond opened in 1880 as a mission of Immaculate Conception in Anchorville. As the congregation grew, it demanded its own church. Architect Peter Dederichs, enhancing his fine reputation within the German community, designed this Gothic-influenced fieldstone structure, dedicated in December of 1913. Parishioners gathered the stones used in the construction from surrounding fields in what eventually totaled 2,000 wagonloads.

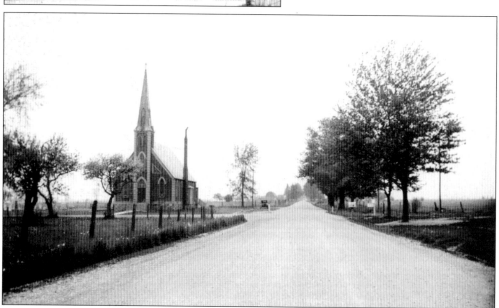

St. Philip Neri in Columbus (formerly Richmond) traces its origins to 1850, serving Irish farmers in the Smiths Creek area. Initially St. Philip was a mission of Our Lady of Mt. Carmel in Emmett before becoming independent in 1908. This photo gives testimony to the serene rural atmosphere that dominated northern Macomb County then. Tragically, this structure was destroyed by fire due to a faulty furnace in 1953.

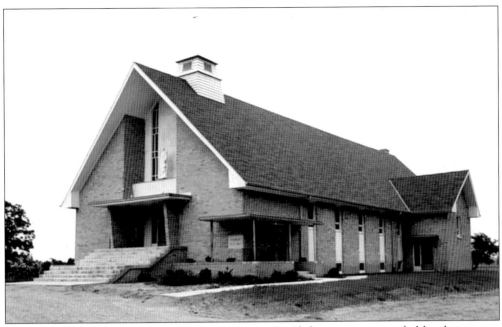

Undeterred by the task that lay before them, the St. Philip congregation, led by their pastor Fr. Lawrence Matysiak, planned for a new church. Ground was broken in October of 1954 and the new edifice, shown here, was dedicated in 1955. Given current demographic trends in the Macomb-St. Clair County region, the congregation at St. Philip Neri is expected to grow sharply in the coming decades.

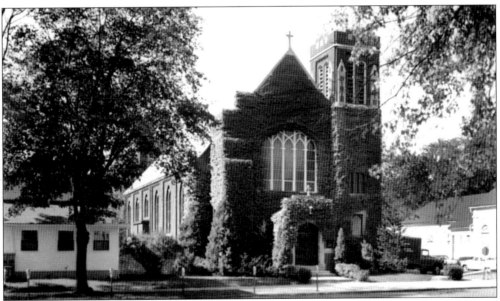

The Catholic presence in Rochester dates to 1900, when priests from St. Vincent de Paul in Pontiac provided regular services. In 1914, Fr. John Needham was authorized to purchase property for a new church at the corner of Walnut and Third in Rochester. A modest chapel built for $3,000 was expanded into this handsome brick structure two years later. A new, larger church was dedicated in December of 1969.

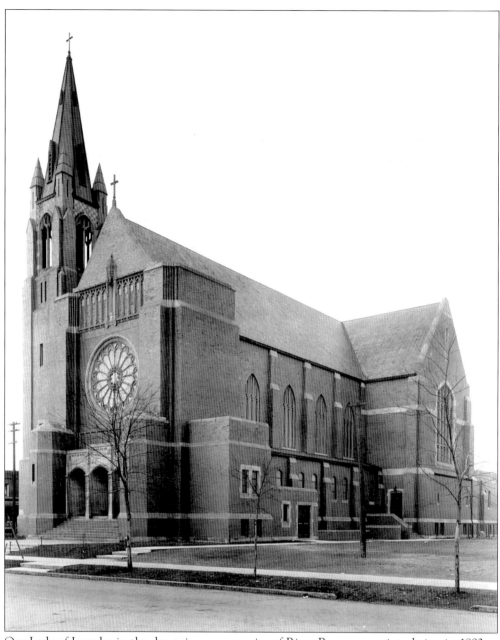

Our Lady of Lourdes in the downriver community of River Rouge came into being in 1893 as a mission of St. Francis Xavier in neighboring Ecorse. But with a growing congregation that eventually totaled 400 families, Lourdes became an independent parish in 1906. By 1922, the congregation had doubled in size to 800 families, rendering the original frame church obsolete. Plans were drawn up for a larger church. The result was this superb interpretation of Gothic architecture, designed by Andrew Morrison and dedicated in May of 1924. The elaborate ceremony included a procession of parish school children escorting Bishop Michael Gallagher across the River Rouge Bridge accompanied by 200 priests. Since that much-heralded event, however, the church has suffered considerable deterioration over the years, particularly the foundation, due to periodic flooding of the nearby river.

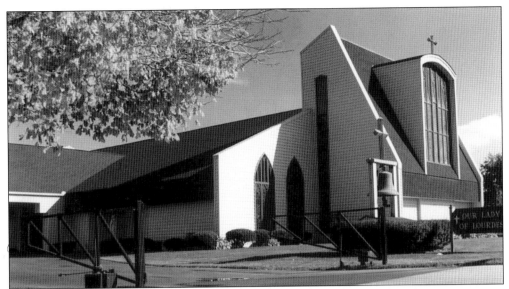

By the late 1980s, it was determined with a great deal of research that the cost to repair the existing edifice would be near astronomical. Rather than burden parishioners with such an expense for many years, the old church was demolished and a simpler, less expensive replacement was erected for the smaller congregation. It was dedicated in 1993. The stained glass windows from the former church were utilized in the new structure.

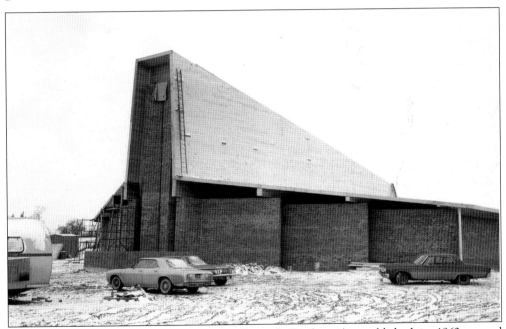

St. John Fisher Chapel in Auburn Hills (formerly Rochester), established in 1962, served Catholic and non-Catholic students attending nearby Oakland University. A brochure to acquaint students with St. John declared ". . . It can be your home while you continue your studies. . . ." Swanson and Associates of Bloomfield Hills designed it in 1966. A growing congregation over the years eventually prompted Cardinal Edmund Szoka to elevate St. John to independent status in May of 1989.

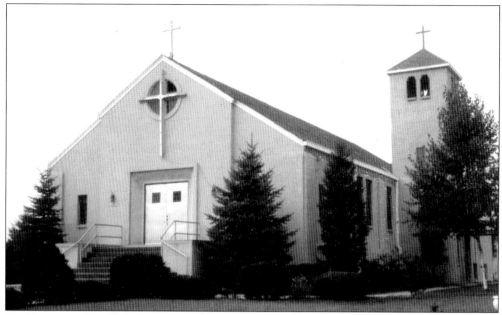

St. Aloysius, in the shadows of Metropolitan Airport on Ozga Road near I-94 in Romulus, began as a mission of St. Anthony in Belleville in 1948 but became an independent parish by 1951. Parishioners contributed their time and skills to do much of the construction and mechanical work themselves and completed the job by 1952. Other parishes donated the three steeple bells, nicknamed "Charles," "Joseph," and "Mary."

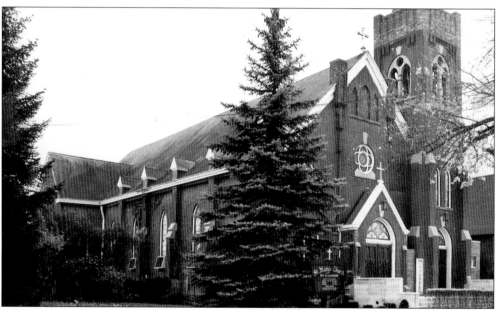

St. Mary in Rockwood (Monroe County) traces its origins to 1834, when Fr. Vincent Badin built a small wooden chapel to serve French settlers living along the Huron River. Initially named St. Vincent de Paul, it became St. Mary by 1847. The present church, shown here, was erected in 1911. Parishioners demolished the previous structure using horse-drawn pulleys and salvaged much of the material for re-use in the new church.

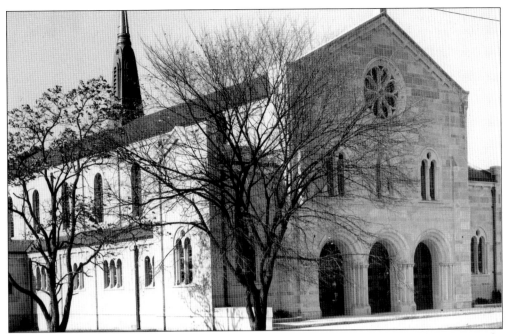

In 1851, the home of Irish immigrant Edmund Loughnane hosted the first worship services for the future St. Mary Parish in Royal Oak. Loughnane's descendants still attend St. Mary today. Located on South Lafayette and Lincoln south of Eleven Mile, the present Romanesque building of Indiana limestone, designed by Arthur Des Rosiers, was dedicated in December of 1954.

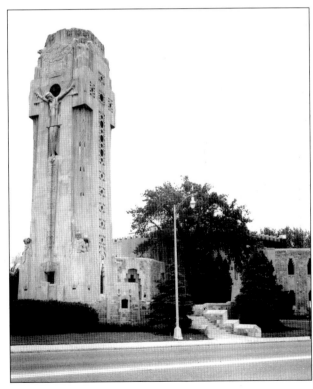

The trademark stone tower at Twelve Mile and Woodward in Royal Oak makes National Shrine of the Little Flower the most recognizable church in the Archdiocese. The tower served as a broadcasting station for Fr. Charles Coughlin, the controversial founder of Shrine of the Little Flower. While other parishes struggled financially during the Depression, Fr. Coughlin's nationally popular radio program prompted generous donations, allowing him to build his monumental parish in 1936.

Tremendous growth in suburban Detroit led to new parishes being formed from the territory of older, established churches. St. Germaine, on Little Mack in St. Clair Shores, was founded in 1957 when neighboring St. Isaac Jogues and Sacred Heart were compelled to re-draw their boundaries. With periodic upgrading, this temporary church, designed by Kessler and Associates and dedicated in October of 1958, continues to serve its congregation to this day.

Perhaps as a fitting tribute to the nautical heritage of the St. Clair Shores area, the interior of St. Margaret of Scotland, designed by Donaldson and Meier, bears an uncanny resemblance to the interior of a sailing ship's hull. The church, on Thirteen Mile between Little Mack and Harper, was dedicated in August of 1957.

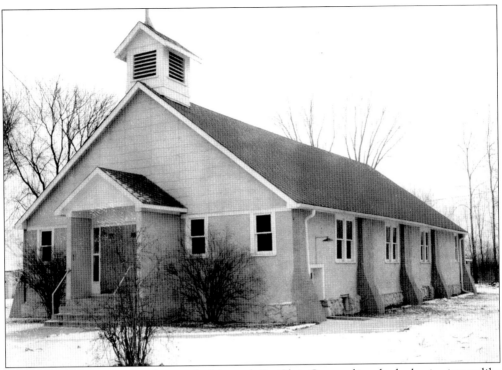

Holy Rosary in Smiths Creek near the Macomb-St. Clair County line, had a beginning unlike most parishes. Whereas many rural churches began as missions and became independent parishes, Holy Rosary started out as an independent parish in 1899 and eventually became a mission of St. Philip Neri in neighboring Columbus. The present Holy Rosary, shown here, was built in 1930 by then-pastor Fr. Gerald Brinton.

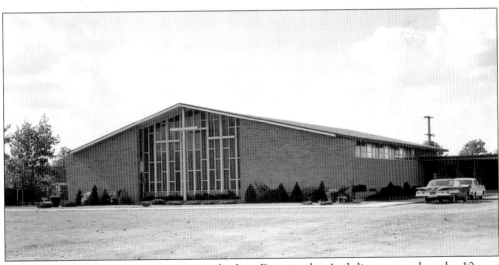

Anticipating a growing population in suburban Detroit, the Archdiocese purchased a 10-acre parcel of land at Twelve Mile and Southfield Road in Southfield in 1952 which became the site of St. Bede Parish three years later. Architect Robert Svoboda designed this temporary church dedicated in April of 1956. When a larger edifice was completed in 1969, the temporary church was then converted for use as the school gym.

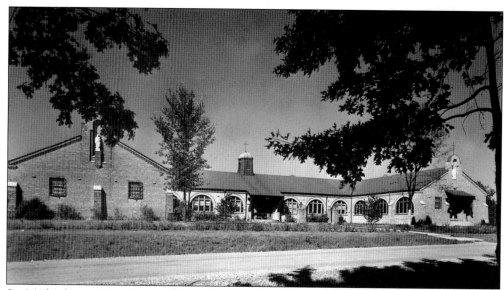

St. Michael, on Code Road at Ten Mile in Southfield, was essentially an outgrowth of the Franciscan friars' presence at Duns Scotus. Founded in 1930, the Franciscans staffed St. Michael. To accommodate growing numbers of Catholics in Southfield, a larger church was built, attached to the already existing school. The completed church (on the right in this photo) was designed in the style of a Spanish mission and dedicated in 1952.

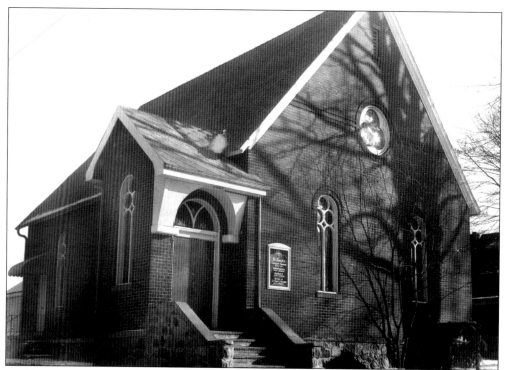

St. Joseph in South Lyon began its existence in 1910 as a mission of St. Mary in Milford and became an independent parish in 1968. The first church, shown here, bears a strong resemblance to the 1950s-styled Cape Cod homes that dot many of America's older suburbs.

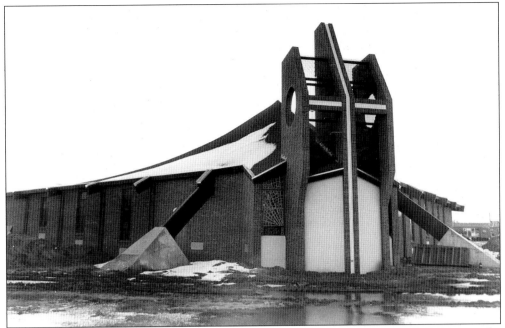

St. Ephrem, on Dodge Park at Seventeen Mile in Sterling Heights, first held services in the Plumbrook Public School in the spring of 1964, then relocated temporarily to the Walsh School which was closer to the proposed building site for St. Ephrem. Architect Joseph DeBrincat designed the new church, shown here nearing completion. Cardinal John Dearden dedicated the finished structure in April of 1977.

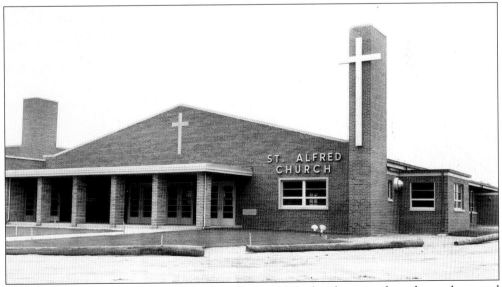

St. Alfred in Taylor was among the first parishes established with money from the newly created Archdiocesan Development Fund. Three former Army barracks from Willow Run, purchased for $18,000, were relocated to Telegraph and Wick Roads and used as the first parish buildings for St. Alfred. The present church, shown here, was dedicated in September of 1960. Although initially considered a temporary facility, it was upgraded and eventually became the permanent church.

Archdiocesan officials recognized the need for a new parish in Temperance in Monroe County and granted permission for the founding of Our Lady of Mt. Carmel in 1957. The first Mass, celebrated at the local Rotary Hall in October that year, drew such a crowd that some persons were turned away. Gratton Construction of Monroe built the present structure, shown here, with its first Mass celebrated at midnight, December 25, 1958.

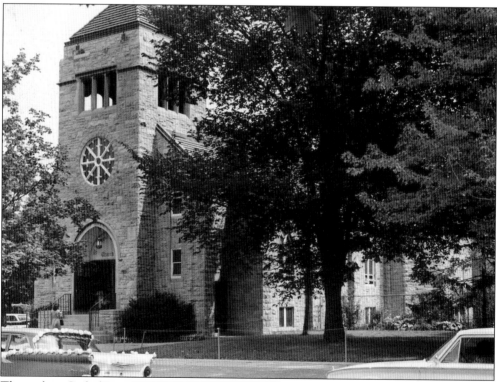

The earliest Catholic presence in Trenton dated to 1849 when a primitive chapel dedicated to St. Joseph was built. A visiting priest from neighboring Ecorse arrived periodically to celebrate Mass. Although mired in poverty for decades, the parish was able to raise sufficient funds to erect this beautiful church of Indiana limestone in 1930. It has since been renovated and expanded to increase its seating capacity from 300 to 500.

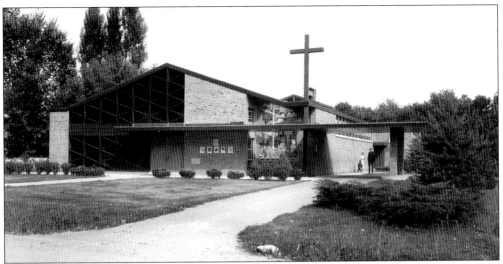

St. William, on Common west of Pontiac Trail in Walled Lake, was established in 1928 as a mission of Our Lady of Victory in Northville. For the next decade, Masses were celebrated primarily in summer, when vacationers crowded the idyllic resort area. As the percentage of permanent residents increased, however, Archbishop Edward Mooney granted St. William independent status in 1939. This modern structure that replaced the outdated original was dedicated in April of 1956.

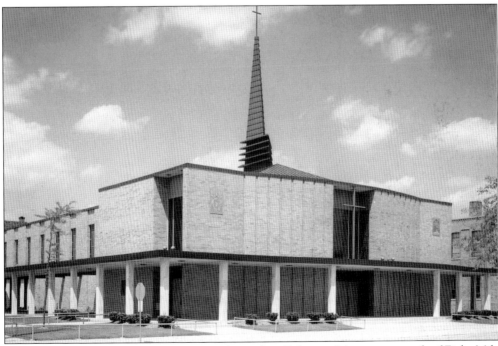

Ascension, the oldest parish in Warren, is located on Fisher and Ascension north of Eight Mile Road. Ascension dates to 1926 when that area was called Baseline. A streetcar line along Van Dyke connecting Detroit with Centerline contributed to the rapid growth in the number of residents. The present church, shown here, dedicated in 1954, was then the largest church of any denomination in Warren Township.

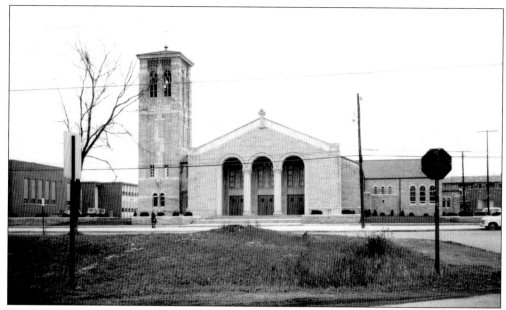

St. Anne, on Mound Road north of Thirteen Mile in Warren, began its existence in a refurbished barn purchased for $14,000. Initially, the parish territory encompassed about 20 square miles. As the population of Warren grew rapidly in the 1960s, the firm of Charles Valentine and Associates was selected to design the permanent church for St. Anne, shown here. It was dedicated in August of 1964.

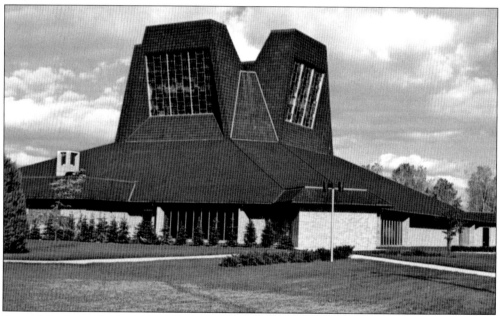

One of the most distinctive rooflines in Warren belongs to St. Edmund Parish. Located on Twelve Mile east of Schoenherr, it was founded in 1961 in response to the massive influx of new residents into Warren. The new permanent church was among the first in the Archdiocese to embody the spirit and directives of Vatican II. Dedicated in April of 1969, it was designed by the Cleveland firm of Fleischman and Associates.

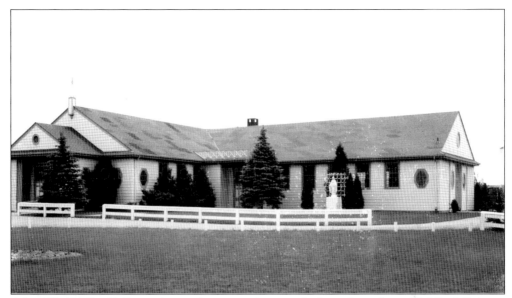

After World War II, Detroit's population exodus stretched northward into Oakland County. Once considered only a summer resort area, it quickly became home for more Catholic families, requiring new parishes. This unassuming structure was the first church for Our Lady of the Lakes (1948) on Dixie Highway in Waterford. Arthur Des Rosiers created this design, dedicated by Cardinal Mooney in 1951. A larger church replaced this building by 1986.

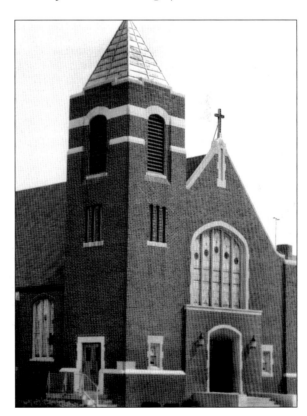

St. Mary, on West Michigan Avenue in the city of Wayne, traces its origins to 1862 when Irish farmers migrated into western Wayne County in search of more land. This third church, erected in 1923, was done in a modified Romanesque style. In 1954, an east-west wing was added to the original edifice, creating a cruciform design.

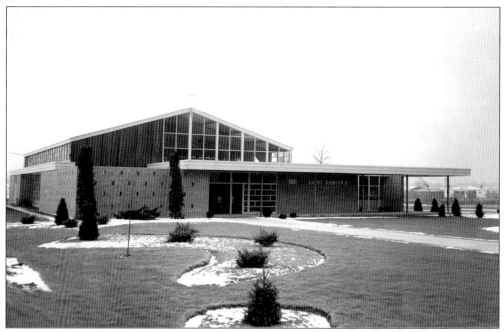

At the time it was founded in 1956, St. Damian, on Joy Road between Middlebelt and Merriman, was first considered part of Livonia, then Nankin Township, before the location became known officially as Westland. What was supposed to have been only a temporary church, shown here, instead served St. Damian's congregation for 45 years before being replaced by a newer, more modern edifice in 2000.

The diminutive wooden chapel in the background is the original St. Patrick church in White Lake, dating to 1840. Listed on the state historic register, it is described as the oldest original church building in Oakland County and one of the oldest in Michigan. This primitive structure and the first parish cemetery are carefully preserved on the grounds of the present St. Patrick on Hutchins south of M-59.

Detroit-area Poles settled in the downriver community of Wyandotte to labor in that town's factories but balked at the long trip back to Detroit to attend Sunday services. Instead they petitioned Bishop John Foley for their own parish and Our Lady of Mt. Carmel came into being in 1899. Located on Superior Boulevard just west of the Detroit River, this edifice has served the congregation since its dedication in July of 1900.

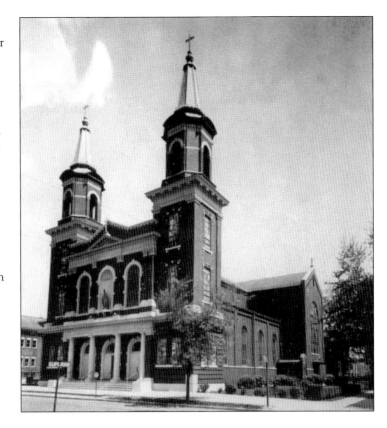

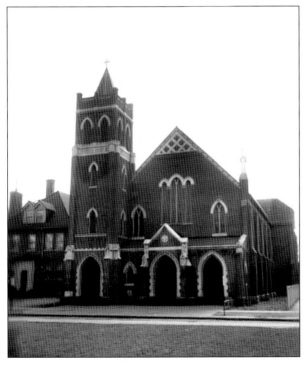

St. Patrick, on Superior and First in Wyandotte, initially served a multi-ethnic congregation composed of Irish, Poles, and Germans; but over time, the latter two groups went elsewhere, leaving only the Irish. The country Gothic church shown here was arduously hand-built by parishioners themselves over a 12-year period, culminating in its dedication in 1883. The structure remains in use to this day.

Sacred Heart in Yale in St. Clair County is the northernmost parish in the Archdiocese. It was founded in 1898 for the handful of Catholics living among the Protestant majority in town. The permanent church, shown here, was dedicated in September 1903 and remains in use to this day. According to local lore, on the day founding pastor Patrick Cullinane chose the name Sacred Heart for his new parish, a violent thunderstorm roared through Yale. Lightning struck several homes and trees adjacent to the church, setting them ablaze, yet the church steeple, the tallest structure in the town, was spared. Was it divine intervention? Perhaps.

Three

CLOSED CHURCHES
RELEGATED TO HISTORY
BY A CHANGING WORLD

Assumption of the Blessed Virgin Mary, on Lovett just west of Grand River and West Warren, was founded in 1911 to serve the growing numbers of Polish residents living northeast of St. Francis D'Assisi who clamored for a parish of their own. This combination church and school served its congregation from the early 1920s until it was closed in June of 1989. The aging structure was demolished shortly thereafter.

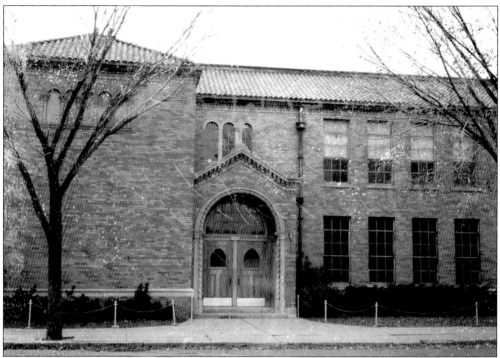

Tucked into the surrounding residential neighborhood on McDougall north of Nevada, Corpus Christi (1923) provided area Poles with an intimate worship experience not always present at a larger, busier parish. Corpus Christi ceased to have its own resident pastor in 1983, and instead became the administrative responsibility of neighboring St. Bartholomew, until the former closed in May of 1989.

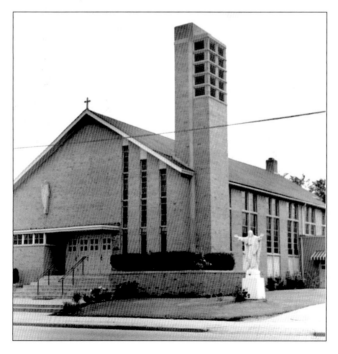

Detroit's Lithuanians were victimized twice in less than a decade when freeway expansion forced them to relocate their parishes. First, St. George on the Detroit-Hamtramck boundary was condemned in 1965 to make room for an expanded I-75, then in 1973, Divine Providence on Schaefer near Buena Vista on the west side (shown here) was razed for I-96. Divine Providence is currently located on Nine Mile near Beech in Southfield.

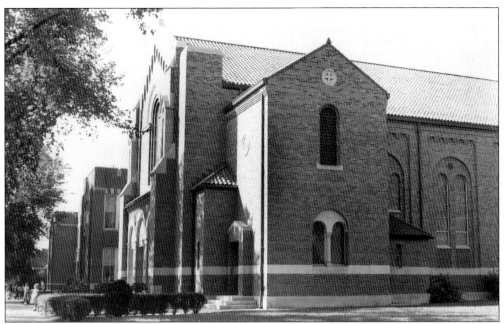

Epiphany, established in 1924 on Orangelawn and Mendota just west of Grand River, at one time boasted a 4,000-member congregation. The permanent church, shown here, was designed by McGrath and Dohmen and dedicated in 1955. Epiphany had the dubious distinction of being the first church to close under the controversial Archdiocesan plan first made public in September of 1988. The final Mass was held on Easter Sunday, March, 1989.

Holy Ghost, on Binder between Nevada and Seven Mile, came into being in 1939 under painful circumstances. When African-American Catholics were denied entry into neighboring parishes because of their race, Archbishop Edward Mooney readily agreed to give them their own church. Architect Edward Schilling designed this modest cinder block structure in 1944. Having outgrown its original need as an exclusively African-American parish, Holy Ghost closed in June of 1989.

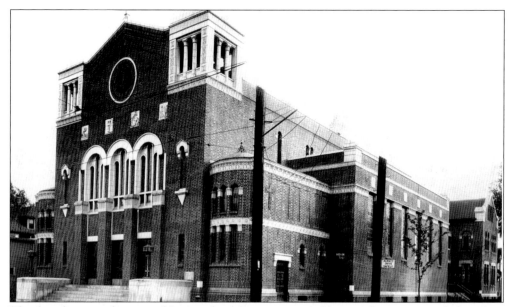

The founding parishioners of Immaculate Conception could never have imagined that their church would one day become the center of the most controversial condemnation proceeding in Detroit history. The parish, at Moran and Trombly, came into existence in 1919 for Poles living on the northern outskirts of Detroit's Poletown neighborhood.

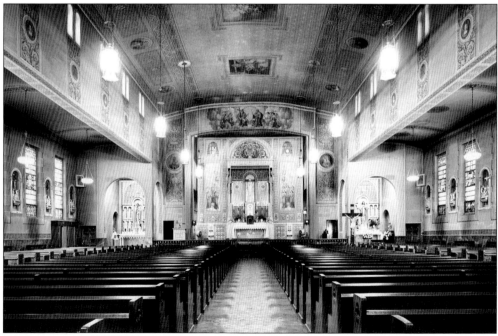

By the 1970s, as more Poles relocated to the suburbs, Immaculate Conception was gradually adopted by newly arriving Albanian Catholics until they became the majority within the congregation. The massive redevelopment plan engineered by the city of Detroit placed the parish squarely in the media spotlight as a handful of devoted lifelong members utilized every tactic possible to save their church from destruction.

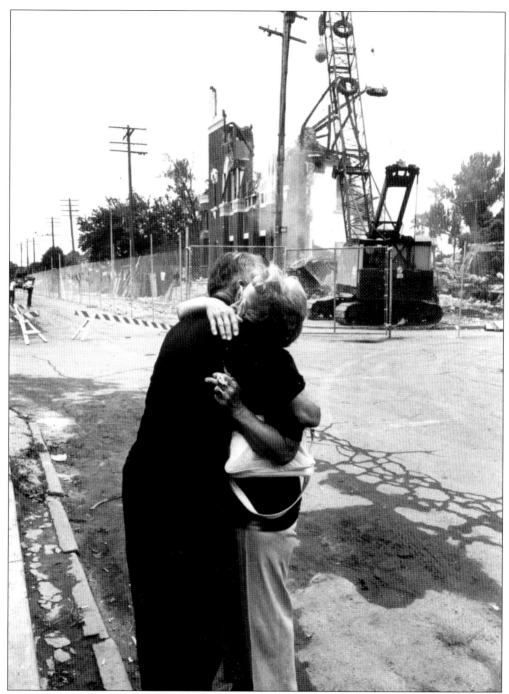

Fr. Joseph Karasiewicz, the last pastor of Immaculate Conception, consoles a tearful parishioner as the wrecking ball begins the unpleasant task of taking down the last standing wall of the church in July, 1981. Despite the valiant efforts of the few remaining parishioners to prevent the razing of their church, the city of Detroit proceeded with the Poletown project as planned. Sadly, Fr. Karasiewicz passed away just six months later. There are those who say he died of a broken heart. (Courtesy Elizabeth DeBeliso.)

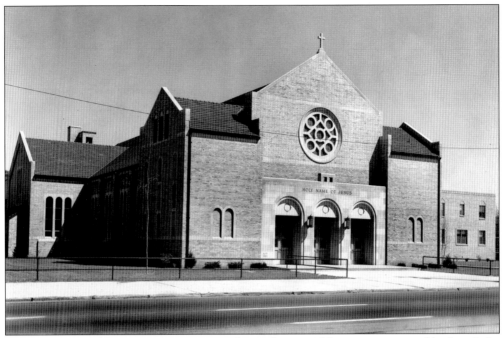

Shortly after World War I, more Detroiters began leaving older, inner city neighborhoods for what was then considered the city's outskirts at Six Mile. Holy Name of Jesus, on Doyle at Van Dyke near Detroit City Airport, was established in December of 1919 for these Catholics. It closed in July of 1990 in anticipation of a plan to expand the airport. That plan would have demolished most buildings nearby, but it never materialized.

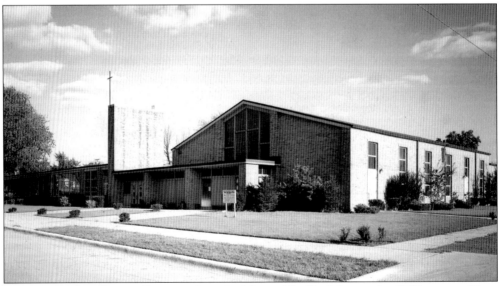

To accommodate the overflow crowds at St. Mary of Redford during the 1950s, pastor Msgr. Edward Hickey advocated the construction of auxiliary chapels in the neighborhood. Mother of Our Savior was the first, built in 1953 on Greenfield and Tyler. It became an independent parish in 1959. One protesting parish staff member refused to leave when the church closed in May of 1989 but the dispute was eventually resolved.

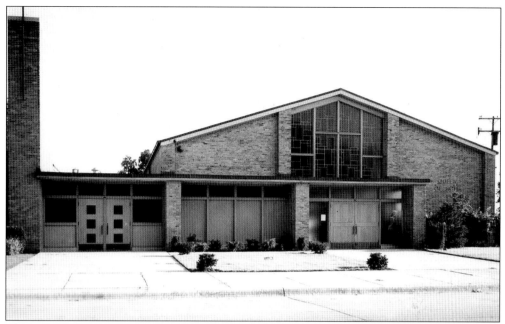

The second chapel to serve the huge congregation at St. Mary of Redford was Our Lady Queen of Hope. It was designed by the firm of Giffels, Vallet and Rosetti, and opened in 1955 on Longacre, one block east of the Southfield Expressway. The parish also operated an auxiliary four-grade elementary school. Our Lady Queen of Hope became an independent parish in 1965 and closed in June of 1989.

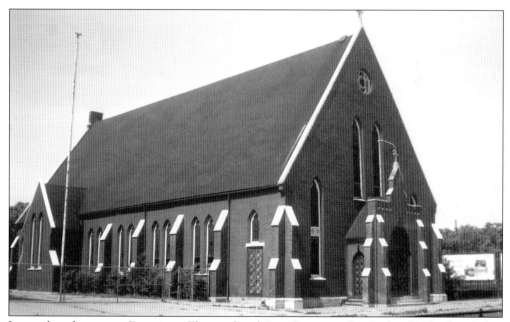

Located in downtown Detroit on Elmwood and East Congress, Our Lady of Help, founded in 1867, initially was a multi-ethnic parish, but beginning in the 1920s, increasing numbers of Italians joined the congregation. An urban renewal project forced the parish to close in 1967 and the building subsequently demolished. An office complex now occupies the site.

Founded in 1943, Our Lady of Victory served African-American Catholics living in Royal Oak Township along West Eight Mile Road. Franciscan priests staffed the parish. Older parishioners painfully recall when a concrete barrier was erected across streets to segregate the black neighborhood from the white. Ruins of that barrier remain in some backyards today. Our Lady of Victory closed in 1973 and the congregation merged with Presentation Parish.

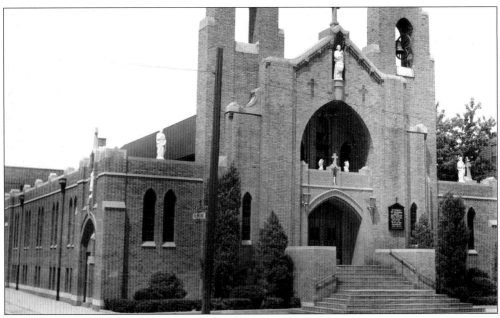

Italians living in the Gratiot-Harper area established Patronage of St. Joseph on Georgia west of Gratiot in 1923. Initially known by its Italian nomenclature, "San Giuseppe," the permanent church was quickly constructed that same year but partially destroyed by fire in 1935. The rebuilt and expanded structure, with an added steeple, became the church shown here. The parish closed in June of 1989.

Detroit's Flemish population, comprised of Belgians and a small contingent of Dutch Catholics, grew disenchanted with their affiliation with French and German parishes and longed for their own church. With the bishop's permission, the Flemish founded Our Lady of Sorrows on the corner of Meldrum and Benson on the lower east side in 1884. A larger church built in 1908, shown here, was destroyed by fire in April of 1963.

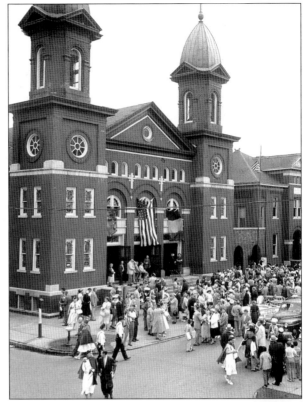

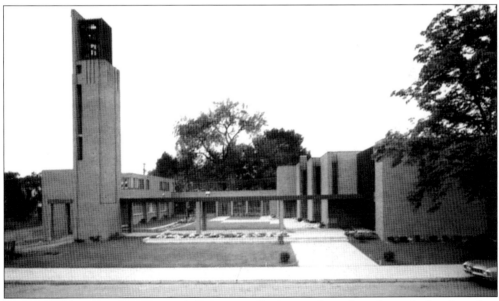

Undeterred by their loss, Detroit's Belgians rallied to replace their burned church with a smaller, modern edifice dedicated in 1966. This contemporary physical plant must have looked a bit out of place in a neighborhood filled with older frame dwellings. With fewer persons of Belgian descent attending, however, Our Lady of Sorrows closed in 2000 and the remaining congregation merged with nearby Annunciation.

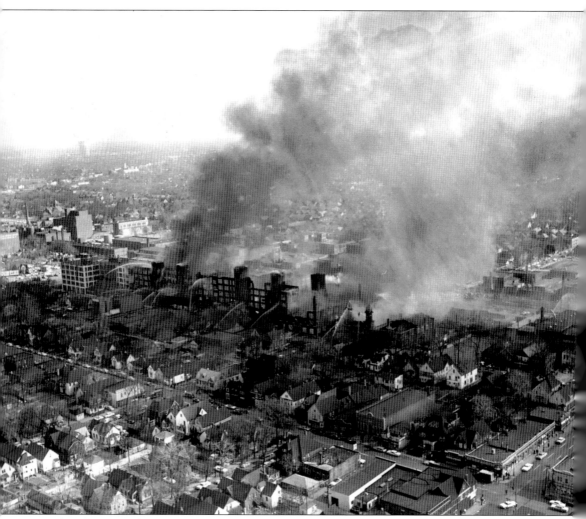

This dramatic photo captures the hellish scenario that unfolded on April 10, 1963, as an abandoned Briggs auto body plant at Meldrum and Benson became engulfed in flames. At the right end of the burning commercial structure, the steeples of Our Lady of Sorrows are faintly visible. One student at the parish school was quoted in the newspaper as saying "We thought it was raining because the sky was so dark." To their credit, the 200 students did not panic but evacuated the school in an orderly manner as they had practiced so often in their fire drills. The five-alarm inferno spread from building to building and threatened the entire block before firemen brought it under control. When the blaze was at last extinguished, it was immediately obvious that the church was a total loss. (Courtesy *Detroit News.*)

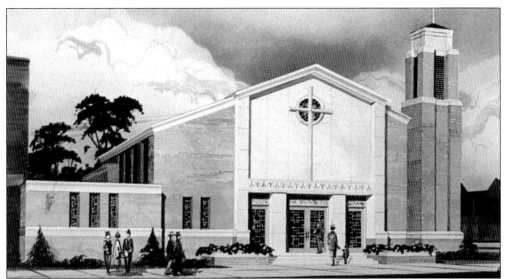

Resurrection, on Miller and Dwyer near the Detroit-Hamtramck boundary, began in 1920 as a Polish National Catholic church but within a year, the parish Board of Trustees voted to join the Roman Catholic Diocese of Detroit. The second church building, shown here, was designed by Walter Rozycki and dedicated in 1962. The parish was closed in June of 1989 and sold to a local Islamic group who converted it into a mosque.

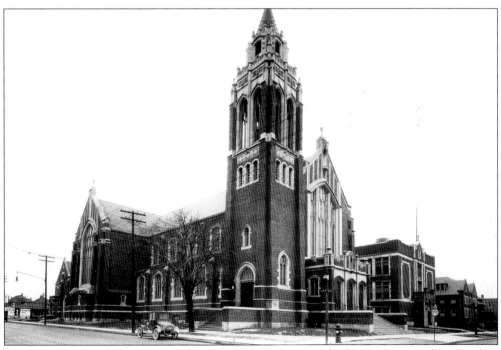

St. Agnes was founded in 1914 in what was then an elegant, suburban Detroit neighborhood on LaSalle Gardens and Twelfth Street, north of West Grand Boulevard. The parish was caught in the middle of the Detroit riots in 1967 but was spared destruction. When it closed in June of 1989, St. Agnes and nearby St. Theresa merged to become Martyrs of Uganda, a new Catholic parish that occupies the same building.

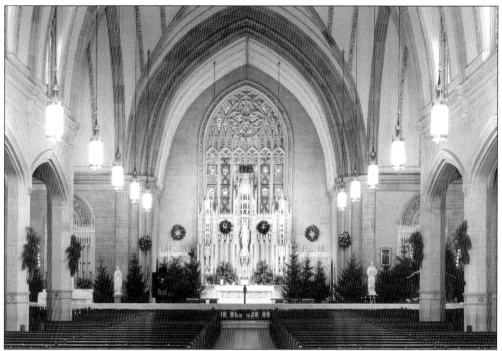

When the city streetcar line was extended to the St. Agnes vicinity, more people moved into the neighborhood, prompting the construction of a larger church. Here, the beautiful interior of St. Agnes with its classic vaulted arches provides ample proof of the parishioners' generosity. Before his heyday as the famous "radio priest," Fr. Charles Coughlin served at St. Agnes as a weekend assistant, commuting from Windsor where he taught at Assumption College.

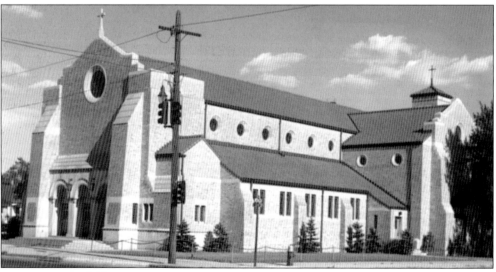

St. Augustine, on Justine and East Davison in northeastern Detroit, founded in 1920, served mainly a Polish congregation initially but in later years became multi-ethnic. This early Romanesque styled edifice, designed by Herman and Simons, was dedicated in 1922. The Augustinian Fathers staffed the parish from the time of its establishment until its closure in June of 1989.

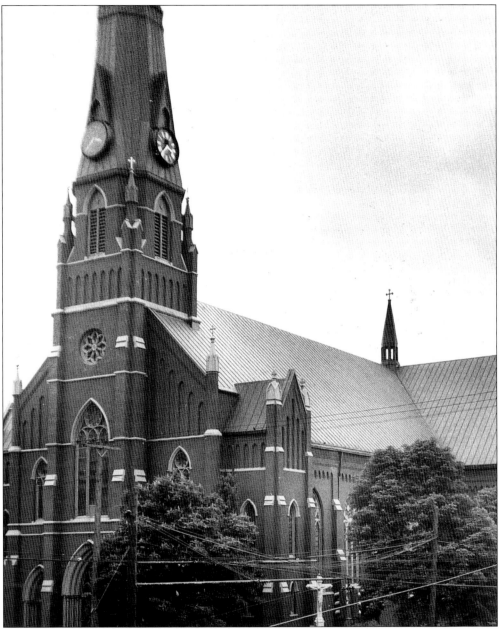

The mother church for Detroit Poles was St. Albertus, situated at St. Aubin and Canfield east of I-75. Founded in 1872, the parish became the heart and soul of Poletown. Architect Herbert Englebert designed the church in a traditional Gothic style but with German-Polish influences. As more Poles settled in that east side area, St. Albertus became the springboard for new parishes: Sweetest Heart of Mary, St. Stanislaus, St. Josaphat, and St. Hyacinth. When the Felician Sisters relocated from Wisconsin to Detroit, they constructed a massive new motherhouse directly across from St. Albertus. The Polish Activities League, which offered assistance to thousands of Polish immigrants, was initially headquartered at the parish. The church closed in 1990, but the property is now maintained by a Polish-American historical society that plans to make the site the focal point of a neighborhood revival.

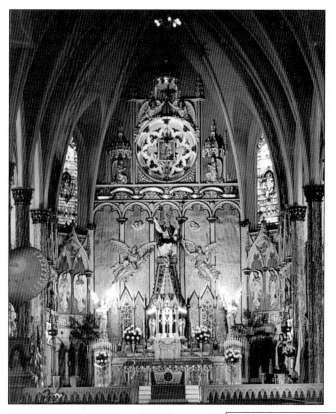

This shot of the main altar at St. Albertus can capture but a fragment of the magnificence of the ornate interior. The church originally cost $80,000 to construct in 1884. To duplicate that same quality of materials and workmanship today, the cost would exceed $20 million! It was said that when Bishop Caspar Borgess viewed the interior for the first time, he was awestruck by the generosity of poor Polish immigrants.

The Detroit Diocese purchased this tiny Lutheran church on Beechwood and Begole west of the former Olympia Stadium in 1927 and re-designated it St. Benedict the Moor, the first parish for African-American Catholics on Detroit's west side. In 1971, a portion of the parish school on 30th and Cobb two blocks away was converted into a chapel and the old church sold. The parish closed in May of 1989.

To better serve the spiritual needs of the hospital staff at Herman Kiefer and Henry Ford hospitals in Detroit, the Archdiocese purchased this home for chaplain Fr. Henry Kenowski, built a modest chapel behind it, and named it St. Bernadette. The chapel was located on Pingree just west of the John Lodge Expressway and dedicated in June of 1952.

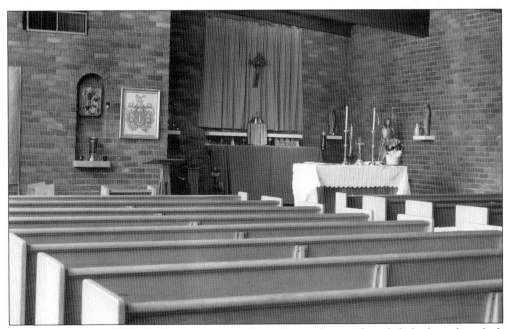

The nondescript, 30-by-50-foot exterior of St. Bernadette Chapel belied a dignified, accommodating interior. Over the years, as administrative responsibilities shifted and visiting priests from other parishes took turns as chaplains for the hospitals, a permanently assigned chaplain was no longer necessary. The chapel closed in 1976 and the facility was sold.

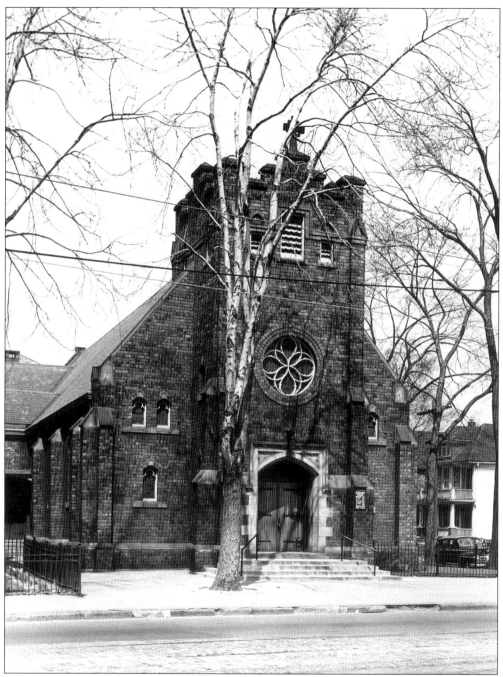

At the beginning of the 20th century, a remote corner of Grosse Pointe Township known as St. Clair Heights (presently Detroit) became the home for St. Bernard Parish. Established in 1899, founding pastor Fr. George Maurer wasted no time in having the permanent church built and dedicated by 1900. That structure, shown here, faces Mack Avenue between Fairview and Lillibridge on the northern edge of Detroit's Indian Village. The Sisters of the Sacred Heart in Grosse Pointe donated the altar that remained in use from the first service on Easter Sunday, April 15, 1900, until the parish closed in April of 1990.

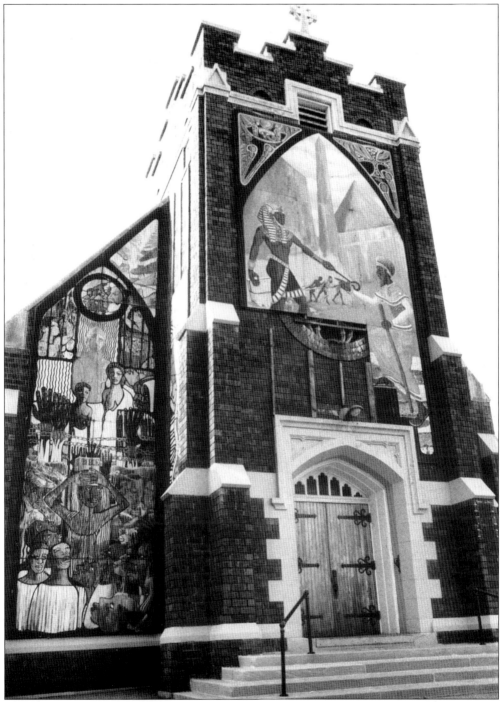

In 1969, Chicago artists William Walker and Eugene Edaw were commissioned by St. Bernard to create a tribute celebrating African-American culture. The result was a stunning series of murals that adorned the façade of the church. These paintings collectively depict the struggles and achievements of Africans dating back to the Old Testament. The Harriet Tubman (called the Moses of her people) Memorial Wall is registered with the state as a historical attraction.

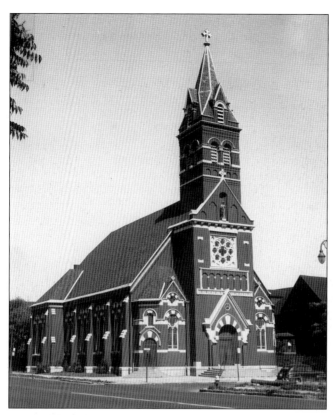

Originally located at 12th Street and Vernor Highway, St. Boniface was founded in 1869 by Germans living west of downtown Detroit. Much of the surrounding residential neighborhood was devoured by the construction of the Lodge Expressway, but St. Boniface survived by opening its parking lot to fans attending nearby Tiger Stadium. Fate finally caught up with St. Boniface when it was closed in June of 1989 and demolished several years later.

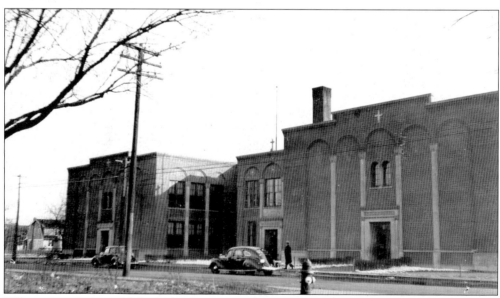

When a parish is established, the first priority is to construct a temporary worship facility. Shown here, c. 1940, is the first St. Brigid church (at right) and the parish elementary school. St. Brigid, founded in 1924, was located on Schoolcraft east of Grand River. It was said that the founding pastor, Fr. Martin Halfpenny, haggled incessantly with the contractor to reduce construction costs down to the last nail.

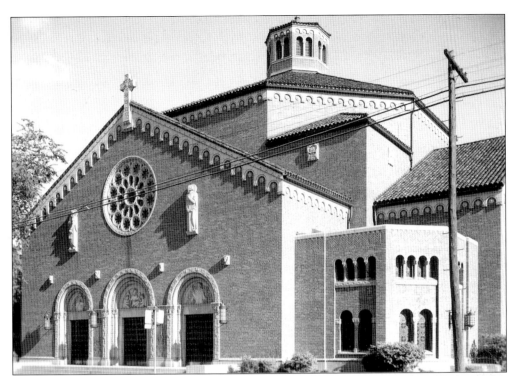

The newer St. Brigid Church was dedicated in 1949. Designed by Diehl and Diehl, the edifice displays some Eastern architectural influences in its domed roof. In the early 1970s, construction of nearby I-96 consumed about 500 homes within the parish territory, which resulted in a steadily shrinking membership until St. Brigid closed in June, 1989.

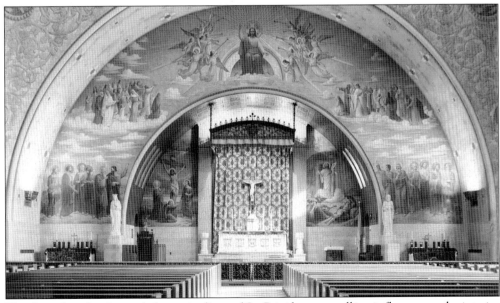

The domed roof and rounded exterior lines of St. Brigid exert a telling influence on the interior of the church with its pronounced arches. Note the exquisite detail of the murals in the altar area as well as the inlaid circular vines and leaves to the left and right of the larger main portal.

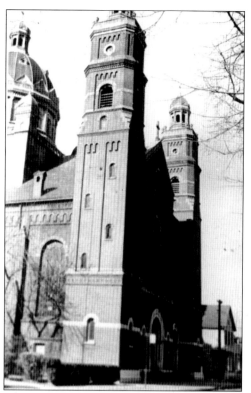

St. Casimir was the second oldest Polish parish in Detroit and the first on the city's west side. Founded in 1882 on 23rd and Myrtle north of Michigan Avenue, St. Casimir eventually became the springboard for the establishment of several newer Polish churches in the vicinity. The first permanent church of a Romanesque basilica design, shown here, was dedicated in 1889.

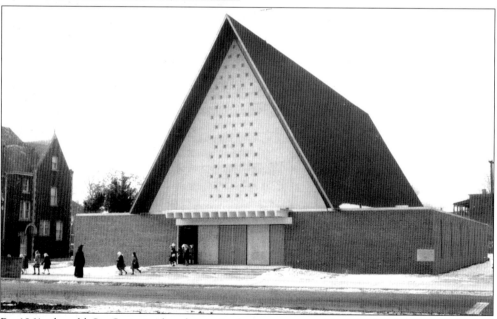

By 1961, the old St. Casimir church required so many expensive repairs that it was deemed more practical and far less costly to simply demolish the structure and build a smaller, modern replacement. The new St. Casimir, designed by the firm of Wakely-Kushner, was dedicated in December of 1962. Interestingly, although the church closed in June of 1989, its elementary school still operates in its original location under the St. Casimir name.

104

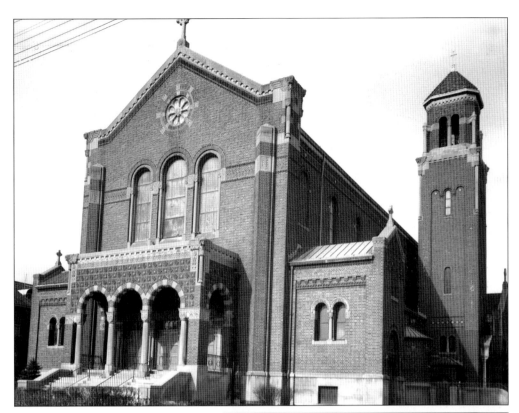

Germans, Belgians, and Italians comprised the first St. Catherine congregation, founded in 1912. The parish was located on the northern boundary of Detroit's Indian Village, on Seminole north of Mack. The church of a Romanesque Italian design, courtesy of Donaldson and Meier, was the centerpiece of the parish physical plant which occupied nearly an entire city block. It was dedicated in October of 1930. Despite attempts to revitalize St. Catherine, the parish closed in April of 1990. The congregations of both St. Catherine and neighboring St. Bernard were combined, and with the permission of Cardinal Edmund Szoka, a new parish named St. Augustine/St. Monica was formed in June of 1990. It now occupies the old St. Catherine church.

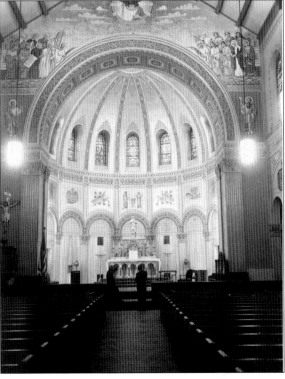

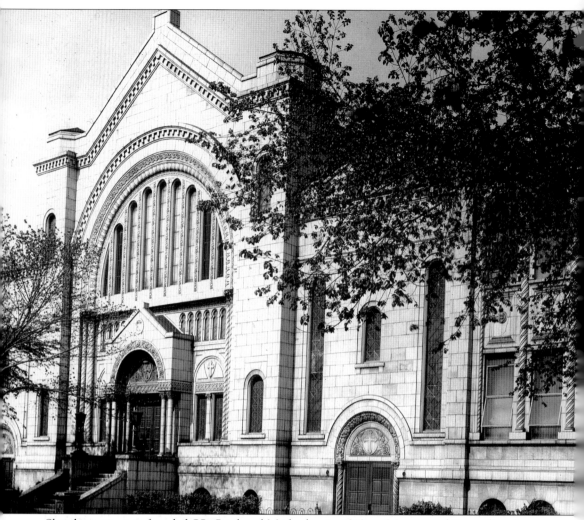

Slovak immigrants founded SS. Cyril and Methodius in 1918 on Marcus and Centerline (now St. Cyril Street), east of Mt. Elliott near Hamtramck. A simple wooden structure served as the initial church, but in the mid-1920s pastor Fr. Joseph Zalibera petitioned Bishop Michael Gallagher for a larger facility. With the bishop's blessing, construction began in 1926 and the first service was held in this building on Christmas Eve, 1929. Although not readily apparent from the photo, the new SS. Cyril and Methodius comprised a substantial physical plant with the church in the center, flanked by the parish elementary and high schools. When the parish relocated to Sterling Heights in 1988, the old church was sold to another denomination but abandoned shortly thereafter. This once-impressive facility is slated for demolition in accordance with a proposed city redevelopment project.

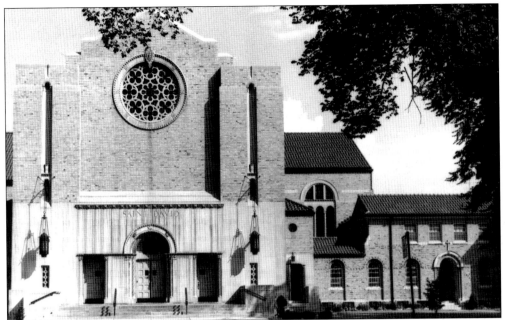

St. David, founded in 1924, was one of the premier parishes in the Archdiocese through the early 1960s, thanks to its highly regarded elementary and high schools. Located on Gratiot and Outer Drive near Detroit City Airport, this new, larger church designed by Herman and Simons was completed in 1948. St. David closed in June of 1990.

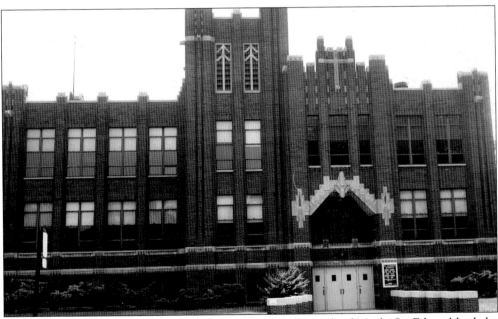

Located in Detroit's Indian Village on Crane and Kolb south of Mack, St. Edward had the distinction of being the smallest parish territorially in the Archdiocese. Established in 1927, St. Edward operated in this building which housed the church in the basement and an eight-grade elementary school on the upper floors. The parish closed in 1969 and merged with neighboring St. Catherine.

By the 1950s, the northwestern corner of Detroit contained one of the last remaining undeveloped areas within city limits. St. Eugene, on Chippewa and Berg just south of Eight Mile, was established in 1954 for Catholics living in the new subdivisions there. It closed in June of 1989. Shortly after closing, the church was renamed St. Andrew Kim and briefly served as the parish for Korean Catholics in the Detroit-Southfield area.

As more Lithuanians settled north of Grand Boulevard in the early 20th century, St. George was founded in 1908 to serve their growing numbers. Located on Westminster and Cardoni north of Holbrook, the parish straddled the Detroit-Hamtramck boundary. The gradual northward expansion of I-75 threatened all property along the route until finally, in 1965, encroaching construction reached the front door of St. George, forcing the parish to close that year.

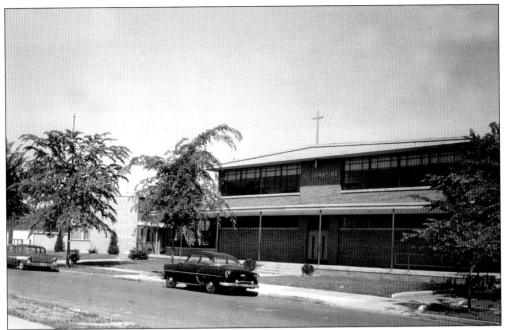

Most new churches originate in growing areas, but St. Ignatius (1948) came into being in an already stable area as an alternative to larger parishes that were some distance away. Cardinal Edward Mooney authorized the purchase of the only available vacant land, a four-acre plot at Camden and Norcross near Harper. The permanent church, shown here, was designed by Walter Rozycki and dedicated in 1954. St. Ignatius closed in June of 1989.

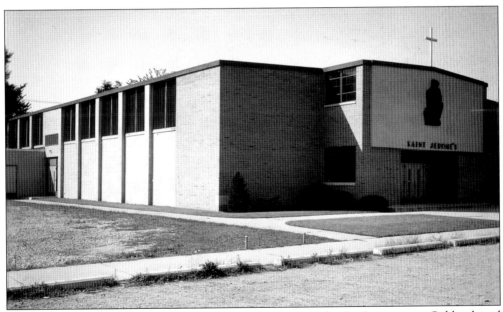

Detroit's Croatian community established their first parish, St. Jerome, on Oakland and Melbourne in 1924. They then built this contemporary structure on Eight Mile just east of Woodward in 1955. In 1996, the congregation relocated to their new church on Wattles Road in Troy and renamed the parish St. Lucy.

When St. John Berchmans was established in 1923, most of its congregation consisted of Belgians living in the Mack-Chalmers area. The Servite Fathers began their service at St. John in 1927 and made up the faculty at nearby Servite High School. When the Servites withdrew from the parish in 1986, St. John closed and the combination church/school building was sold. The remaining congregation joined neighboring St. Juliana.

St. Joachim began its existence in 1875 as a chapel to serve French Catholics living east of Woodward Avenue. The church shown here, on East Fort and Dubois near downtown, was completed in 1885. By 1967, St. Joachim was vacated and demolished to make room for urban redevelopment that included modern offices and apartments known collectively as the Elmwood Project.

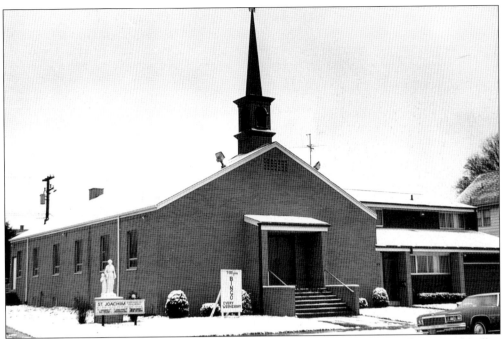

Forced out of their old parish, east side French residents relocated St. Joachim to a smaller, already existing church building on French Road and Montlieu, directly across from Detroit City Airport. Services that included a French language Mass continued at that location for more than 20 years until declining membership forced St. Joachim to close in June of 1989.

St. John the Evangelist, on East Grand Boulevard between Sargent and Griffin, was founded in 1892 to serve the Germans living on the northern outskirts of Detroit's Poletown—but in time, various ethnic groups would make up its congregation. The permanent church, designed by Gustav Mueller, was completed in 1924. The parish closed in 1981 as part of the area redevelopment for a new General Motors assembly plant.

This rare aerial view shows the neighborhood that was home to St. John the Evangelist. The church is situated in the lower middle. To the left is the rectory while the school is to the right. The large building at the far right is St. Joseph Mercy Hospital. When the city of Detroit announced its plan to assist General Motors in constructing a new assembly plant by acquiring the necessary land, the targeted area encompassed more than one square mile and required the removal of hundreds of homes, churches, and businesses. Unlike their counterparts at nearby Immaculate Conception, the St. John congregation accepted its fate without protest or fanfare. To give some idea as to the vastness of the Poletown project (bearing in mind that what is shown represents only a fraction of the structures involved), everything you see here no longer exists.

Located on Lonyo between Michigan Avenue and I-94, St. Lawrence was founded in 1922 to serve Poles on Detroit's far west side. This economical structure, designed by Leo Bauer and completed in 1927, housed the parish school on the upper floors while the basement functioned as the church. The parish closed in June of 1989. St. Lawrence's final pastor, Fr. Stanley Kasprzyk, referred affectionately to his parish as "our little Bethlehem."

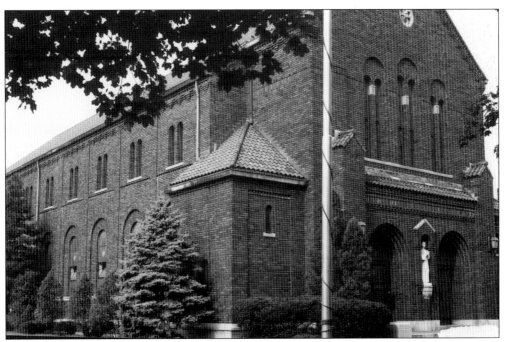

St. Margaret Mary, on East Warren and Lemay, began its existence in 1920 as the sister parish of St. Bernard to the south. The permanent church was dedicated in June of 1931 during the depths of the Great Depression. Although a thriving parish for many years, by 1982 the congregation dwindled to only 65 individuals and when the building required expensive repairs, the only practical solution was to close the church.

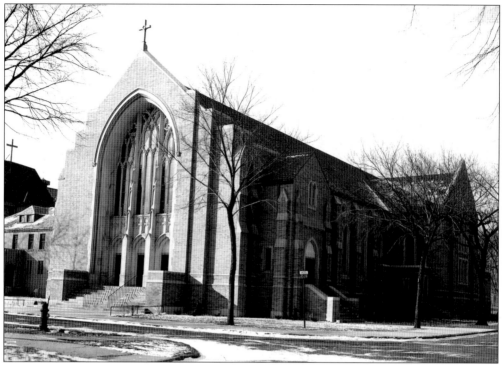

Tucked into what was once an upscale neighborhood between Jefferson Avenue and the Detroit River, St. Martin was founded in 1923 on Drexel and Averhill. McGrath and Dohmen designed the permanent church. St. Martin closed in April of 1989 and its congregation merged with nearby St. Ambrose. The Archdiocese still owns the building and has mothballed it for a possible future reopening as the area around it is redeveloped.

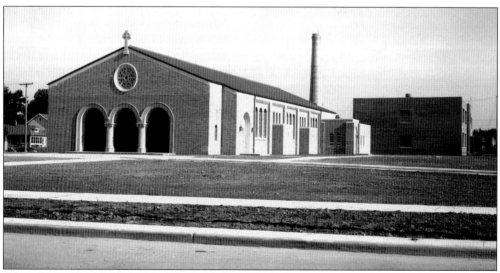

One of the most attractive of Detroit's closed churches was St. Monica on Lyndon and Heyden near Evergreen on the city's far west side. The structure, with a decidedly Spanish influence in its architecture, was designed in 1956 by Leo Clark and included a large, semicircular driveway in front that is standard at many suburban churches today. St. Monica closed in June of 1989.

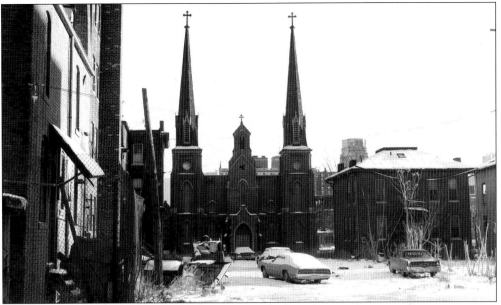

Detroit's once-elegant 19th century neighborhoods had become blighted eyesores by the early 1970s. The congregation of St. Patrick at John R and Adelaide had relocated to the former St. Therese Chapel one-half mile north, while the original church, purchased by the city of Detroit, deteriorated. Authorities speculate that a homeless person, in trying to keep warm, accidentally set the structure ablaze, destroying the abandoned hulk in May of 1993. (Courtesy Bruce Harkness.)

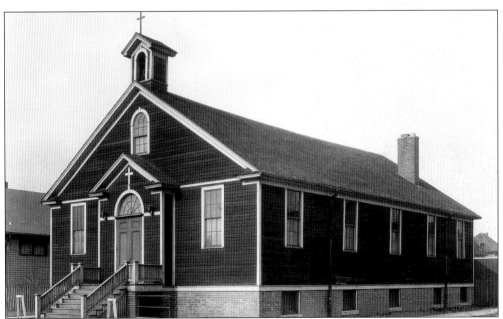

Lithuanian immigrants crowded into southwestern Detroit seeking employment in the Delray area factories. St. Peter, on Longworth and Mullane one block west of Springwells, was founded for them in 1920. This temporary church, with only minor modifications to the exterior, eventually became permanent. The parish closed in May of 1995 and the building was converted into a neighborhood activities center under the administration of nearby All Saints Parish.

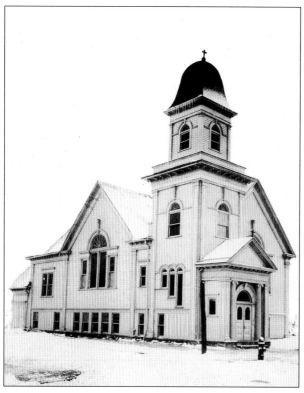

By 1920, Detroit had the largest concentration of Maltese anywhere in the United States. As more Maltese arrived seeking jobs, an aging Episcopal church at the corner of Fourth and Plum near Tiger Stadium was purchased for them and renamed St. Paul. Parishioners did the repairs themselves. St. Paul thrived for three decades until 1952, when construction of the Lodge Expressway forced the closure and demolition of the church.

Ford Motor Company's sprawling Rouge complex in southeastern Dearborn employed scores of Maltese. To serve their needs, the Archdiocese authorized the establishment of St. Bernadette on Dix Road in Dearborn in 1943. The parish operated in this combination church/school building until gradually dwindling numbers of Maltese forced St. Bernadette to close in June of 1998. An Islamic group then purchased the property.

Parishioners at St. Bernadette constructed this simple yet attractive shrine to Our Lady of Lourdes near the church that allowed visitors to park their automobiles, kneel in prayer and contemplation and perhaps light a candle before going on their way.

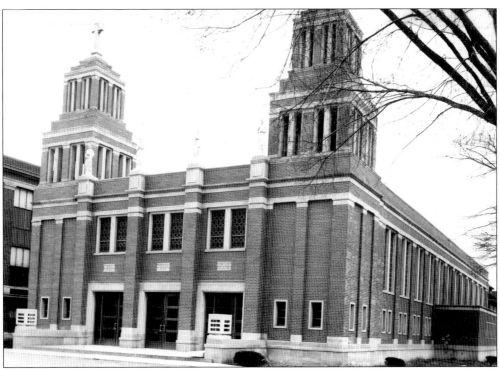

St. Philip Neri, on Charlevoix and Dickerson north of Jefferson Avenue, was founded in 1927. Arthur Des Rosiers designed this permanent church in 1955. The area around St. Philip Neri suffered from years of decline and neglect until the parish closed in June of 1989. After closing, the former church served briefly as a community food depot.

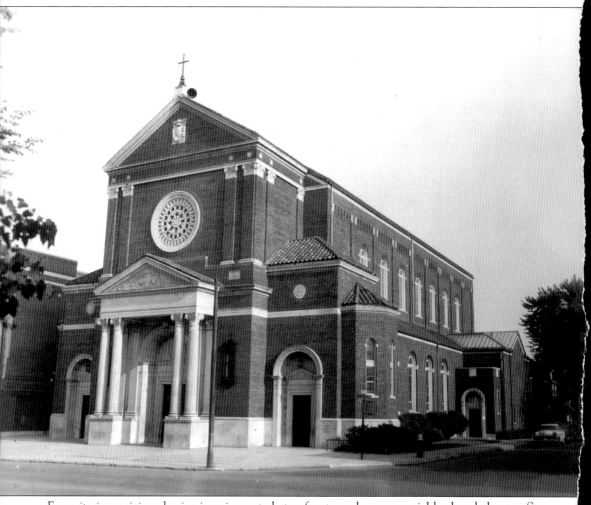

From its inauspicious beginnings in rented storefronts and even a neighborhood theater, St. Rose of Lima grew into one of Detroit's larger parishes, thanks to generations of autoworkers who made up its congregation. Founded in 1919 on Kercheval and Beniteau north of Jefferson Avenue, the permanent church was designed by Van Leyen, Schilling and Keogh in 1927. During the Detroit riots of 1967, St. Rose served as the headquarters and staging area for federal troops ordered to quell the civil disturbance. In the aftermath of the rioting, many residents fled Detroit for the suburbs, resulting in a steady loss of parishioners. After nearly 60 years of service, the aging church required so many expensive repairs that the small congregation could not bear the cost. It was demolished in 1984.

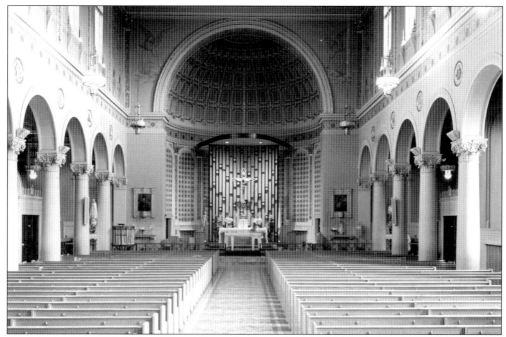

The elegant, spacious interior of St. Rose symbolized the culmination of the dream of its founding pastor, Fr. Edward Taylor, who envisioned a church worthy of his hard-working and generous parishioners. When the church was razed in 1984, the remaining congregation relocated to a makeshift chapel in the basement of the school building until St. Rose closed in August of 1989.

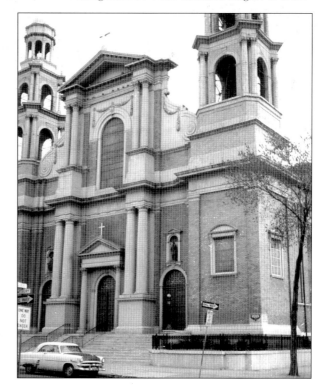

As more Polish immigrants settled in the Poletown area, placing a greater burden on existing parishes, the diocese was compelled to act. In 1898, an old Lutheran church at Medbury and Dubois just west of Chene, was purchased and renamed St. Stanislaus. This new church of Baroque influences, designed by Harry J. Rill, was dedicated in 1913.

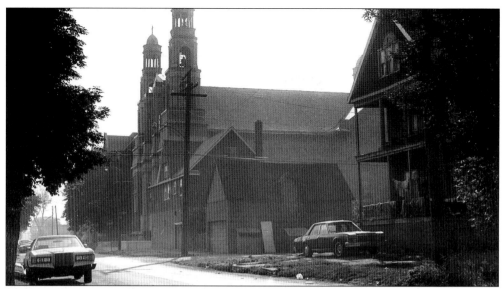

This shot of St. Stanislaus with its forlorn streets provides sad testimony to the deterioration of Poletown. The expansion of I-94 in the early 1960s eliminated many of the residential neighborhoods south of Hamtramck and contributed to St. Stanislaus' inexorable decline until the parish closed in June of 1989. (Courtesy Bruce Harkness.)

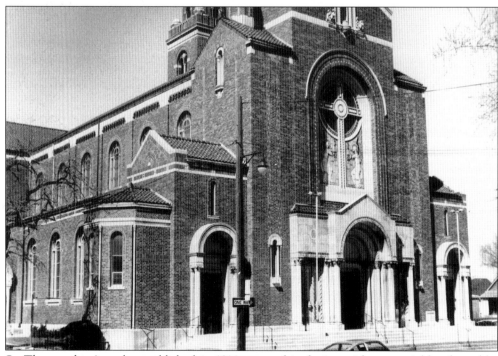

St. Thomas the Apostle, established in 1914 as a multi-ethnic parish, was quickly adopted by area Poles with the appointment of Fr. Stanley Skrzycki as pastor two years later. The parish was located on Townsend and Miller near the intersection of three major thoroughfares, Harper, Van Dyke, and I-94. The permanent church, shown here, designed by Van Leyen, Schilling and Keogh, was dedicated in 1924. It closed in June of 1989.

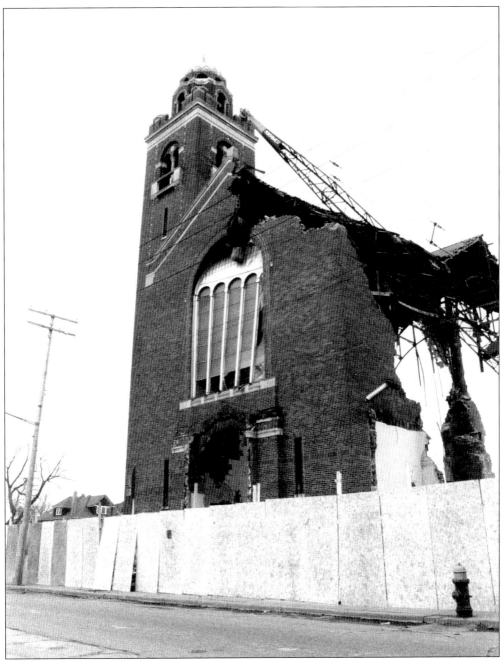

Nearly every church closed by the Archdiocese in 1989 had a prospective buyer, but St. Thomas the Apostle was not among them. To prevent further deterioration and vandalism, the Archdiocese reluctantly decided to demolish the structure in December of 1991. Here, the wrecking ball labors on the belfry and side entrance. When the task was completed, nearly all of the physical plant that was once St. Thomas (church, rectory, elementary school, high school, and activities center), occupying an entire city block, was gone, leaving only a vacant lot. The stained glass windows, however, were removed prior to demolition and now grace the church of St. Therese of Lisieux in Shelby Township. (Courtesy Victor Pruchniewski.)

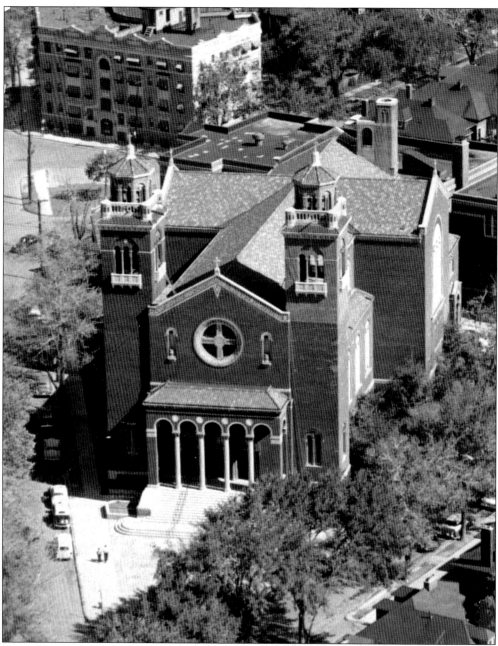

Founded in 1915, St. Theresa of Avila was uniquely situated on a triangular "island," bounded by Quincy, Pingree and Blaine streets, one block east of Grand River. The permanent church was built over a two-year period, culminating in the dedication ceremony held on May 16, 1926. St. Theresa thrived for many years, operating both an elementary and a high school. In the years following the devastating 1967 riots, however, the congregation gradually shrank to the point where the parish closed in June of 1989. Offers for the property were scarce, due to a lack of adequate parking and the fact that the church and school buildings were both heated by the same boiler, a design utilized in the early 20th century as a cost-saving measure. The buildings remained the property of the Archdiocese until they were finally sold in the summer of 2003.

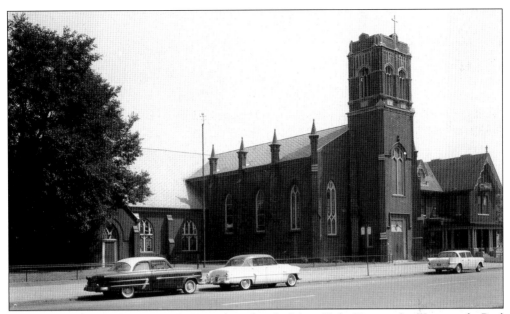

When Detroit's Irish outgrew their mother church, Most Holy Trinity, St. Vincent de Paul was established for them in 1865. Situated at 14th and Marantette south of Michigan Avenue near Tiger Stadium, St. Vincent boasted the first separate Catholic high school building in the state. The school drew more parishioners to St. Vincent beginning in the later years of the 19th century through the early years of the 20th century.

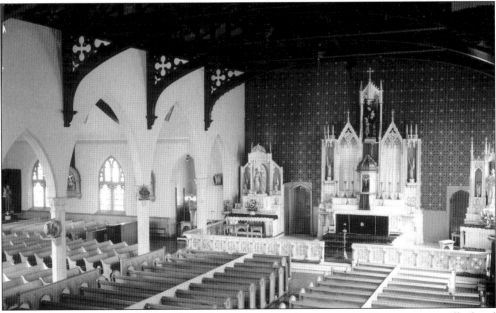

Although founded to ease the overcrowding at Most Holy Trinity, St. Vincent eventually faced its own crowding problems, resolved by constructing an addition to the church, visible at left. St. Vincent fell victim to one of many urban renewal projects in Detroit during the 1960s, and the parish was closed and demolished in 1965, 100 years after its birth. The remaining congregation merged with neighboring St. Boniface.

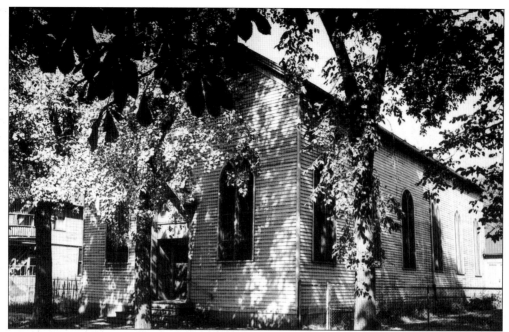

Bohemian Catholics in Detroit who emigrated from the German-Czech region of central Europe made St. Wenceslaus their parish, dating to 1870. Located on St. Antoine and Leland south of Mack, this modest frame church remained nearly unchanged for the duration of its existence. The parish was closed and razed in 1962 as part of yet another urban renewal project.

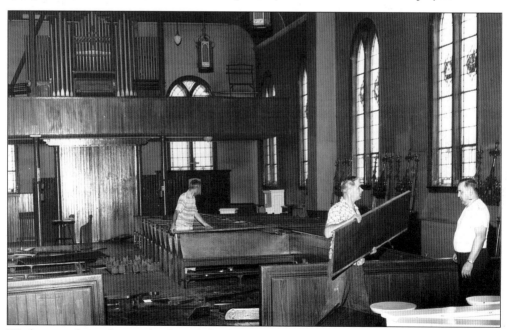

Workers go about their task of carefully dismantling pews inside St. Wenceslaus prior to its demolition in 1962. For many years, the Archdiocese has made every effort to salvage as much as possible from buildings targeted for demolition, so that these fixtures may be reused at other locations.

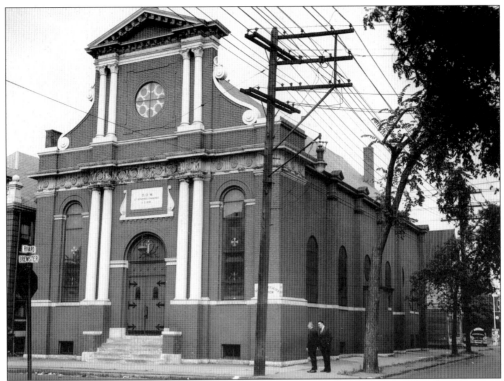

Detroit's earliest Italian immigrants settled in an area just north of what is now downtown and established their first parish, San Francesco, at the corner of Rivard and Brewster, south of Mack, in 1896. When the church was closed and demolished in 1966, the congregation used rented storefronts for more than a decade before finally relocating to suburban Clinton Township in 1978.

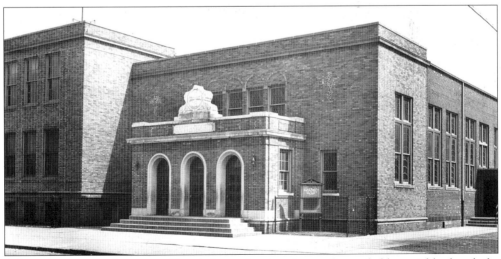

Italians living near downtown Detroit began leaving the confines of older neighborhoods for what was then considered the city's outskirts, north of Grand Boulevard. They established Santa Maria parish in 1919 on Cardoni and Rosedale Court near the Detroit-Highland Park boundary. When Detroit embarked on a renovation project in that area, Santa Maria, along with many homes and businesses, was forced out of existence and demolished in 1973.

St. Norbert, on Woodsfield between Inkster and Telegraph roads in Inkster, was founded in 1951 to serve growing numbers of Catholics moving out of Detroit to the newer suburbs of western Wayne County. Rather than assume the burdensome cost of building a larger church, the congregation opted instead to expand the temporary structure, resulting in the edifice shown here. St. Norbert closed in 1998 and merged with neighboring St. Kevin.

Slovenians founded St. John Vianney Parish in 1926 at 12th and Geneva west of Woodward in Highland Park. George Diehl designed this modest building, dedicated in July of 1933. After World War II, as Slovenians became fewer in number, the parish welcomed African Americans into its fold. Tragedy struck in 1978 when a fire destroyed a part of the church, and rather than rebuild, St. John closed.

In 1907, Detroit Czechs established St. John Nepomucene at Ash and Lawton north of Michigan Avenue and dedicated the church shown here just one year later. By 1977, the construction of I-96 eliminated most of the residential neighborhood around St. John. That, coupled with the need for costly repairs to the aging edifice, compelled the closing of the church in October of 1977 and its demolition shortly thereafter.

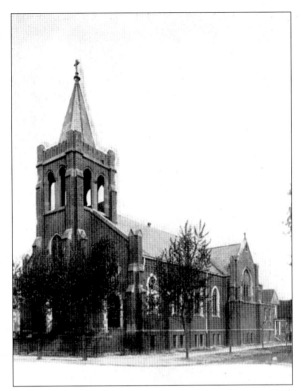

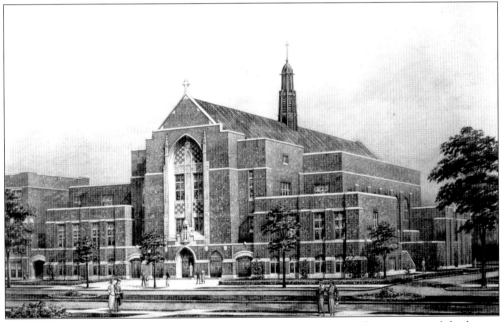

Visitation (1920), on 12th and Webb west of the Lodge Expressway, became one of the largest parishes on Detroit's west side. The permanent church, designed by Carey and Esslestyn, was completed by 1925. After the 1967 riots, the exodus of residents contributed to the steady decline of "Visy," as it was affectionately nicknamed. The cavernous structure became too great a burden for the diminishing congregation and had to be sold.

When Visitation was sold in 1983, the remaining parishioners relocated to the former convent down the street at 14th and Webb. The chapel, visible here at the far left of the building, became the new church. The size of the convent gives evidence as to how many sisters once lived there. Regrettably, even a downsized Visitation was unable to survive, and it finally closed in June of 1989. Despite the loss of these churches over the years, their place in Archdiocesan history is assured. Meanwhile, the work of the Catholic Church in southeastern Michigan continues as the demand for its services and ministries increases. In retrospect, the mere presence or absence of a building does not define the Church. Instead, it is its people, inspired by faith, who devote themselves to the service of others regardless of their physical surroundings.